THE BIG ACTIVITY BOOK FOR ANXIOUS PEOPLE

THE BIG ACTIVITY BOOK FOR ANXIOUS PEOPLE

JORDAN REID AND ERIN WILLIAMS

A TarcherPerigee Book

tarcherperigee

An imprint of Penguin Random House LLC
penguinrandomhouse.com

First trade paperback edition 2019

Most TarcherPerigee books are available at special quantity discounts for bulk purchase for sales promotions, premiums, fund-raising, and educational needs. Special books or book excerpts also can be created to fit specific needs. For details, write: SpecialMarkets@penguinrandomhouse.com.

Library of Congress Cataloging-in-Publication Data
Names: Reid, Jordan, author. | Williams, Erin.
Title: The big activity book for anxious people / Jordan Reid, Erin Williams.
Description: New York : TarcherPerigee, 2019.
Identifiers: LCCN 2018050289 | ISBN 9780525538066 (paperback)
Subjects: LCSH: Anxiety. | Stress management. | BISAC: SELF-HELP /
 Stress Management. | HUMOR / Form / Comic Strips & Cartoons. | ART / Popular Culture.
Classification: LCC BF575.A6 R34 2019 | DDC 152.4/60207—dc23
LC record available at https://lccn.loc.gov/2018050289
p. cm.

Printed in the United States of America
12th Printing

Book design by Erin Williams

DEAR ANXIOUS PERSON,

Hi!

First: Relax. (Don't you love it when people tell you to relax?! Us too! Works every time.) You are not condemned to a life of overthinking and sleepless nights. You are, in fact, completely normal. You know who's not normal? Those people in your feed who are all sparklingly happy and carefree and look like extras in a Skittles commercial. Let's get real: Nobody smiles that much unless they're hiding something. Like, say, crippling anxiety.

These days, having anxiety is simply part of the human experience: We live in a world rife with corrupt power structures, unspeakable violence, natural disasters, and PowerPoint presentations on the percentage of statistics accounting for the ratio of decimals in the aggregated digital realm that you triumphantly finish giving, only to discover the poppy seed lodged between your front teeth. Here's the truth: Everyone you know is worried that they have a poppy seed stuck in their teeth, too. It's called psychology.

Whether your anxiety is so intense that you require professional assistance—in which case we congratulate you for asking for help—or light enough that you often make it through the day without a full meltdown—in which case, congratulations for that, too—this is the book for you. We've got pages and pages of activities to make you feel less alone, to inspire you to laugh through your fears, and to help you figure out what to do when it's 3 a.m. and you're wide awake worrying about whether or not you cc'd the right "Bob" on that email. (You did. Probably.)

If you're having a bad day, try coloring in the soothing grandma on page 85. If you're having a really bad day, check out our step-by-step instructions on how to build your own underground bunker on page 94. Before your next flight, make sure to comb through our comforting facts about airplanes (which are, just so you know, extremely safe modes of transport) on page 7, and if your nail beds look anything like ours, definitely take a second to look over the alternatives for cuticle destruction on page 89.

And remember: You're in good company. Anxious people are some of the funniest and most interesting and creative humans on the planet. We know, because we're two of them, and we're great.

Take comfort, and take care. We hope you love this book.

Jordan & Erin

HOW TO USE THIS BOOK

1. Pick it up whenever the mood hits: in the morning, instead of listening to the news (spoiler: something bad happened); during your lunch break, so when Ron from marketing strolls by to update you on the development of the lump on his upper inner thigh you can look way too busy to chat; late at night, if you've already tried toe yoga, making sheet angels, and the other suggested Activities for Insomniacs on page 130.

2. This book is loosely divided into three chapters, but you can feel free to ignore that fact, because activity books are not known for their plot structure. Flip forward, flip back, pick a page at random and start there. Life can be a pain what with the rules and responsibilities and such, so consider this book the opposite of that, and do whatever the heck you want with it — even if what you want to do is regift it because you're completely happy with every aspect of your life and have no anxiety at all, and you have no idea why Carol thought that this should be your Secret Santa present, because all you wanted was a Bed Bath & Beyond candle, like everybody else got.

3. If you're so inclined, take a picture of your various creations and tag us on Instagram at @bigactivitybook — we want to scc (and sharc) your gcnius.

ALL ABOUT ME

draw your face here ⤶

TELL ME MORE

Add up your points earned to access your totally scientific anxiety profile.

RELATIONSHIP STATUS

☐ Single (1 point)

☐ In a relationship (2 points, because you have to answer the question "So when are you guys getting married?!" every day)

☐ Married (3 points, because now you have to bear constant, theoretically decades-long witness to another human being's anxieties, in addition to your own)

☐ This question stresses me out—stop asking me this (4 points, and go take a nap; we're only on page 3 and it sounds like you might need one before we move on)

CURRENT SOURCES OF ANXIETY (check all that apply)

☐ School (1 point)

☐ Work (1 point)

☐ Money (0 points; money makes everyone miserable)

☐ Relationships (0 points; see above)

☐ The volume of bacteria currently residing on my cell phone (2 points)

☐ The fact that someone thought I was so anxious I needed this book (3 points)

☐ All of the above, plus everything else (4 points)

BEHAVIORS ASSOCIATED WITH SLEEP (check all that apply)

☐ . . . Um, sleeping? (0 points, and, hooray, you're a unicorn)

☐ Writing down my to-dos in a little notebook next to my bed, just like Oprah suggests (0 points, only back-pats)

☐ Trying this spot, then that spot (1 point)

☐ Trying this position, then that one (1 point)

☐ Counting how many fluorescent green lines make up each number on my clock (2 points; pro-tip: watching the second hand on an analog clock is both far more satisfying and far more likely to result in sleep)

☐ Ceiling observation (2 points)

☐ Staring at your peacefully slumbering partner with barely suppressed rage (3 points)

☐ What is sleep? (4 points)

YOUR FAVORITE WAY TO RELAX

☐ Meditating (0 points)

☐ Feeling guilty that I'm not meditating (1 point)

☐ "Meditating," aka thinking about Nutella, then telling myself not to think about Nutella, then thinking about it even more (1 point)

☐ Meditating so well that it's actually just falling asleep (0 points; this is an awesome talent and you should be celebrated for it)

☐ Compulsively ingesting your nails (2 points, unless you're chewing on your toenails; if so, 4 points, and also ew)

☐ Food (1 point, unless it's Yodels, in which case you also get the Excellent Taste in Baked Goods Award)

☐ Rereading *The Bell Jar* (3 points)

☐ Creating a fort out of empty pizza boxes and used Psychology 101 textbooks, then burying yourself in it (4 points)

HOW DO YOU FEEL ABOUT SOCIAL SITUATIONS?

☐ What's not to love about a party?! Friends! Family! Fun! WOOOOOOO (-5 points)

☐ I'll go for the ranch dip (1 point)

☐ They always sound like a good idea, but then when it's time to start interacting I develop sudden-onset narcolepsy (2 points)

☐ If the hosts have a dog, I'll make it through (3 points)

☐ Not even if they serve Lexapro on tap (4 points)

YOUR PERSONALIZED ANXIETY PROFILE

0–10 points: Novice Worrier. You probably wander around listening to Bob Marley and eating macarons one nibble at a time so you can savor their delicious flavor. Good for fucking you.

10–20 points: Intermediate Worrier. You probably should take a chill pill but are not yet at the point where being told to "take a chill pill" makes your brain explode out of your ears.

20–30 points: Expert Worrier. You specialize in 4 a.m. symptomchecker.com searches and existential agony.

30–40 points: Total Worry Domination. You firmly believe that worrying is a tool that God and/or evolution gave us in order to help us not get eaten by large cats, and anyone who wants to take your anxiety away from you will have to pry it from your cold, dead hands. You are going to love this book.

TOP FIVE

WHAT ARE YOUR BIGGEST, TOTALLY IRRATIONAL FEARS?

getting a B+

being eaten by wolves

ax murderers

10% battery

1. _____

2. _____

3. _____

4. _____

5. _____

WORD ASSOCIATION TIME!

Write down the first word that comes to mind when you read each of the below.

On trend: _____

Baby: _____

Sears photo studios: _____

Tequila: _____

Artisanal: _____

Influencer: _____

Disney on Ice: _____

Hustle: _____

Organic: _____

WWE match: _____

Community theater: _____

Dodgeball: _____

Stand-up comedy: _____

Politics: _____

Amateur night: _____

Open floor plan: _____

Hive mind: _____

The future: _____

Baby birdies: _____

Journal:

Doing this exercise made me feel: _____.

Clearly I am in need of a little more: _____.

COMFORTING FACTS ABOUT AIRPLANES

If you do not currently reside on a Caribbean isle—and you don't, because if you did you likely would not be holding an activity book for anxious people—you may occasionally find yourself wanting to go somewhere nicer than where you are right now. Unfortunately, that may involve being sealed into a metal tube with lots of people coughing and babies wailing and a seatmate named Rod who wants to tell you about the movie script he's working on.

Luckily, Rod is probably the worst thing that will happen to you on your flight, because while those wings may look as though they can just pop off, chances are they won't.

Some facts to make you feel better next time you get pre-boarding heart palpitations:

- Commercial air travel is the safest form of transportation in the world. Really.
- Airplanes usually have TVs, and TVs usually have cartoons.
- Most pilots aren't drunk right now.
- There's free food, assuming you consider a plastic bag containing ten almonds "food."
- For some reason, tomato juice tastes good on airplanes.
- The chance of dying on a commercial flight is 1 in 30 million. You are much, much more likely to be killed by the airplane food than by the actual airplane.
- Airplane doors are tapered like bath plugs, so they're bigger than the door openings—meaning they can't open outward, and the pressure inside the cabin means they can't open inward. So even if someone is determined to refine her skydiving technique midflight, she literally cannot.
- Noise-canceling headphones actually do cancel noise.
- The worst part of turbulence is the spilled coffee.
- While you walk to the bathroom, you can enjoy the rows and rows of people sleeping with their mouths hanging open. (Never gets old.)
- Maybe there'll be one of those moms who gives everyone presents because her baby is crying.
- 96% of people involved in airplane accidents survive.

HOW TO:

HANDLE IT WHEN YOU GO OUT TO DINNER WITH FRIENDS, HAVE A SALAD, AND SOMEONE SUGGESTS YOU ALL "JUST SPLIT" THE BILL

Going out with friends is super fun, unless you have social anxiety, in which case go ahead and skip this page because you're probably staying home anyway.

Slightly less fun: that moment when the check arrives and your friends (all of whom are richer than you, and all of whom drank three $17 martinis while you sat there with your free water and your wilted baby arugula pile) are all "Oh, let's just split it!"

WHAT TO DO WHEN THIS HAPPENS:

Complain about money

Complain about your rent. Complain about your taxes. Complain about your salary. Eventually someone will probably pay for you just to make you stop.

Choke on something

Restaurants tend not to make their patrons pay for food that almost killed them, so maybe you'll get that dish comped! Be careful not to actually die.

Did you just get an urgent text from Aunt Viv?

Pretend you got an urgent text from your great-aunt once removed. You didn't even know you had a great-aunt once removed! Weird. You better check on that. (Note: works best when followed immediately by the Irish goodbye.)

Deal with it

Go into it knowing that you'll end up paying for someone else's fucking $30 duck appetizer anyway, and eat all the delicious things.

THINGS YOU THINK ABOUT AT 3 A.M.

1. The enormity of the numbers associated with your student loan interest and the age at which you will have paid it off.

2. How Carol was coughing by the coffee pot and now your throat is starting to feel a little scratchy, too. Goddammit, Carol.

3. How many days after the "purchase by" date can you still eat deli meat?

4. What exactly happens if you eat old deli meat?

5. How if you fall asleep right now you can still get four hours of sleep! GO TO SLEEP RIGHT NOW, BRAIN. (Screaming at one's brain to stop working is a highly successful strategy.)

6. The excruciating passage of time, culminating in the death of yourself and every single one of the people you love most.

7. Is your passport expired? It probably is. You should go check.

8. Whether the front door is locked and, if not, whether a serial killer is at this very moment standing in your living room fondling a bread knife and a pair of underwear you left on the couch.

9. Bedbugs.

HOW MANY WORDS CAN YOU MAKE OUT OF THE LETTERS IN

OVERTHINKING

RIVETING HONK

HORNET VIKING

THINGS THAT USED TO MATTER

Remember when life was simple, and you weren't constantly faced with your own dwindling mortality? That was nice.

Let's take a stroll down memory lane, past the desiccated corpses of things you once cared about.

BRAND-NEW COMPOSITION
 NOTEBOOK
COOL NEW RECORDER
FRIENDSHIP BRACELETS
LE PENS
BEING TALL ENOUGH FOR THE RIDE
GETTING TO STAY UP LATE
ETCH A SKETCH SKILLS
LITTLE DEBBIES
WHO GOT THERE FIRST
WHOSE TURN IT IS NOW
HAPPY MEAL TOYS
GOBSTOPPERS
SNOW
BEING AWESOME AT PIG LATIN
WHAT TIME *TINY TOON ADVENTURES* IS ON
FAVORITE PURPLE CRAYON
IF CARRIE STILL LIKES YOU
WHAT'S FOR LUNCH
ANALOG ANYTHING
COLORED CHALK

VALENTINE's DAY CARDS
YOUR PARENTS' APPROVAL
YOUR PARENTS' PRIDE
YOUR PARENTS' OPINION
YOUR TEACHER's APPROVAL
YOUR TEACHER's PRIDE
YOUR TEACHER's OPINION
ANYONE's OPINION
RECESS

```
G F K A V N H C J W X U C I G S S B Y N P N B M B G K C G I B X D F C B Y W B R
N Z R H A P P Y M E A L T O Y S S O H P G E M E D Q B R F V T F C X O R H P R N
S O V I E K L V G H M Q B Z X Q U E U A G L I A S I U F N N X I D P L N D X A T
S X S X E E M M C C M S H L Z R G Z C U X N W F B Q J O C O W W G K O S K Q N K
J D T I B N A A N S T P E P P W Y Z W E G D A A Y T Y D F I B X Z Z R M B W D S
J A R A S I D R B O H N F A L L K Q Z T R N F N X A O Z P Q Q Y K J E Z Q G N H
M W X A N N H S P H K B R X U F E I A R I R M M R G X Y V I R W L I D M I R E F
G D M D C K O P H K O E L V C S P L U H E E N C Z T A N O N F Q F U C D W U W G
I N V B Q Y E O U I N T N I T A L G I P T A E M O S E W A G N I E B H Z F H C E
W N I R D R A S T T P G D K M E R Y Y H B L L L T Y F H I H H U M X A L V G O T
Y O O Z T E Q A S Y N Y R O G B A V Q R W Y I F S S B D R Z T W H C K V R G P I
M S D G U Y P N W E W I U A Y A R W U A O Y T O L Q G T D I C S W J K L T X O N
R E H G O P N V O Y N G T J C Q V P D W N F J L N E U Y Q I A V E M K F K Q S G
J G W Z R T S A M P H I S E A E E H J D S S I J O V O V N P E Y D E Q D X W I T
T K G O O P T H G F W G T C M T L H M Y B K S N I O Y A B K W S X Q G W V Y T O
H A V W M R B H O O K C M N I I Z E O D S C F O N C S F J H H K S O T B Z H I S
D A O N X E P R E H L C F R E G T S T H F D D I I P E W W J O O L D J E B M O T
L C Z S J D T E P R N A O G D L E T C S B K H N P D K X H R S H Y H F S Y Q N A
E B L T L H T A H H E V N D L I A T A O D V Q I O I I X J A E Y F F W P Z B N Y
I O G U E T P N F W A F H A B K E V X H Y V Z P S A L R Q L T Y W L J R Q L O U
M B N R Z M L L F F M S I B X K B E F Y W P W O E I L N P Z U S X X C W M W T P
O P I Y O U R T E A C H E R S A P P R O V A L S N B L H F R S F Z J G F U E L
I D L V X J M O K Y M D L A S F J H I Y H F O T O M I C Y J N K U O V Z V U B A
E H O O N M V I P I E K H L W T Y R B Q D T M N Y Z T V V Z I J A H R W D R O T
S R S F K V W H A L P C W T R O D F W W Z L Z E N G S R C F S E M F K L O W O E
S K H N J T O G T W T E N V U D V J Z W M L Z R A I E Y T E I O Z Q X Q U G K R
Q F N Z I J J T Q E E U S R I I W Y I F N G V A U X I A D H T L Q Q Y H P N N K
V O E W L D I O U S K V P X R B N D K R K G V P F I R G Y T N O M W M Z O S C B
G Y E B F L M V U N H A E F U B P I Q D V Q E R L F R V U F O A Y A H A N R H H
Y O U R T E A C H E R S P R I D E H F N L G K U S I A C M B W F H T W E L G Q A
J K V Z J Z M X X E M V T K O J Z E V X T B V O F W C R K M F L D Q J P A Z N P
R I S O M C B E N E R S N E P E L U N K J S Y I F F J W X Z Z K G A R C E S R
J A L Z B B W T Z G C J Z E B R Y T A X Y A S H A S I T H Y L K D H B S Z Q T Q
J I J I Z N S Y D H U Y G X H B Y N R M I I R E D R O C E R W E N L O O C L T
C V B Z L S Y A Y M R A S D D M B C N V M M R V R T N L J H H J I K G O O D
N Z Y S R J T M N M K C W N J G I G W S K D I N V Q Q D F T O W X J Y I J B
O N N I E A W L C N C G X H I C X F B T R W O E D T L F B H W S S S Q E F D U
L C D G U T V P M U N E U S K T S I R Z F O Z F G J C K Q C Z E B L U E B S M V
X E U N F Q O T B W U P H X K P S R P C Q A L C H J N O C O F V J W P J A G I P
```

MAIL YOU DON'T WANT TO GET

Every once in a while, a check lands in your mailbox and you're all OH YAY THE MAIL ARRIVED GETTING MAIL IS SO MUCH FUN! Every other day, though, getting the mail is the worst, because it has things like bills, which is why the best solution is to let it sit for all eternity and be slowly digested by multiplying stacks of coupon pamphlets.

- Anything addressed to the last person who rented your apartment or house. You will either have to (a) forward it to them like a decent human being (ugh, stamps, envelopes, remembering to do such a thing) or (b) throw it away, thereby violating federal law and subjecting yourself to soul-crushing guilt (okay, the guilt lasts only as long as the trip from mailbox to trash, but still).
- Anything from your alma mater, particularly when they are asking for money (LOL) or inviting you to a reunion at which you will learn all about how your peers have spent the years since college becoming Elon Musk or something.
- Thank-you cards. Anyone who writes a thank-you card is doing so solely to transmit smugness and superiority via mail carrier. The only effect that a thank-you card has on your life is forcing you to wonder about the appropriate length of time to hold on to a thank-you card.
- Bills for less than $3, because then you have to spend precious minutes of your fleeting life writing a check for less than $3, finding an envelope, finding a stamp, and forgetting to mail it (thereby incurring late fees, thereby making the bill more than $3).
- The *New Yorker*, because you will read six pages, flip through the cartoons, and then add it to the stack of *New Yorkers* in the corner of your apartment, none of which you will ever read unless you are placed under house arrest.
- Wedding invitations when you are single.
- Destination wedding invitations to places like New Jersey.

GET THROUGH THE WORKDAY WITHOUT APOLOGIZING!

AVOID ENTERING A DOOR WHILE SOMEONE IS EXITING! OVERSLEEPING! FORGETTING TO BCC! USING CAROL'S SPECIAL COFFEE CREAMER SHE BROUGHT FROM HOME! BEING LATE FOR YOUR OWN MEETING!

START

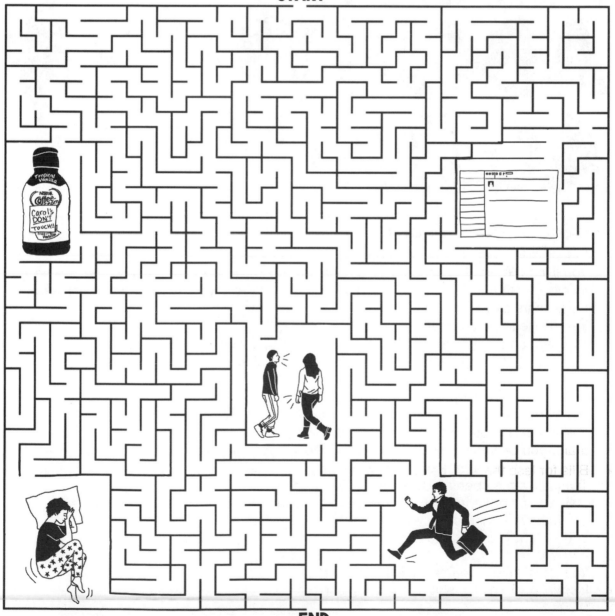

END

FUN FACTS ABOUT AGING!

Sure, you can no longer sleep past the crack of dawn (whyyyyyy?) and your upper arms are starting to look like your grandmother's, but on the plus side . . .

- Pain builds character! Especially back pain. And knee pain.
- You lived through the rise and fall of Vine, so you know not to waste any time getting involved with trendy new apps until the majority of the people using them are at least thirty years old.
- You can learn to crochet with zero irony.
- You can randomly scream "WHAT THE FUCK ELSE WAS I SUPPOSED TO DO TO SOMEONE WHO STOLE ALL MY MONEY?!" in public, and people will likely just keep on going.
- You get to say exactly what you think about people, even if what you think is that they're the worst, because what are they going to do, hit you?
- Staying at parties past 10 p.m. is lame.
- You technically have more money, even though you also technically have much more crap to pay for. (Focus on the "more money" part.)
- Trying to remember words is kind of like a game!
- Instead of wondering how your life's going to turn out, now you can just wonder how it would have turned out if you'd made better choices.
- You look at your parents and experience empathy, as opposed to rage.
- You realize that grown-ups are just large children.
- You realize that everyone is in it together.
- It's fun not to give a shit about being cool.

FIVE ASSHOLES EVERYONE KNOWS...
ON THE ROAD!

Sometimes assholes feel the need to take to the streets and let their assholery seep into a 4,000-pound hunk of metal for maximum impact.

1. The asshole who thinks he looks cool smoking.

2. The asshole at rush hour who thinks the other lane will be faster.

3. The asshole who rocks truck nuts.

4. The asshole who's in your goddamn way.

5. The asshole who's so witty she can't stand it.

PUBLIC SPEAKING

A DIAGRAM

When confronted with a room full of people, all of whom are staring at us and expecting us to be eloquent, our bodies have a clear action plan. It includes pooping.

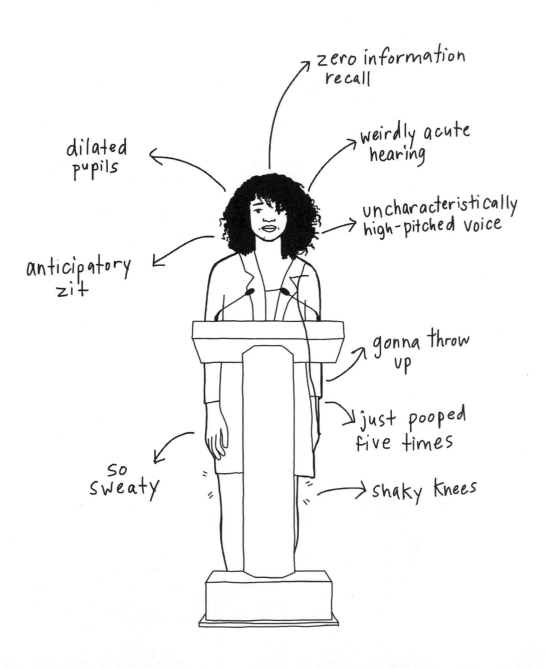

zero information recall

weirdly acute hearing

dilated pupils

uncharacteristically high-pitched voice

anticipatory zit

gonna throw up

just pooped five times

so sweaty

shaky knees

SOME TECHNIQUES THAT MIGHT ACTUALLY HELP

ADMIT HOW NERVOUS YOU ARE.

75% of Americans are anxious about public speaking; in fact, surveys have shown that people are more afraid of it than of death. Putting your fears out in the open can take away their power.

INTERACT WITH YOUR AUDIENCE.

Asking them questions and making them a part of what you're doing makes all involved feel more comfortable (and makes you seem like an engaged, articulate speaker).

STAND WITH YOUR WEIGHT EVENLY DISTRIBUTED ON BOTH FEET.

This is an old trick to make a speaker appear more confident and relaxed, but it also makes you feel more confident and relaxed.

PICTURE YOURSELF STANDING ON A MOUNTAINTOP, YOUR ARMS RAISED VICTORIOUSLY OVER YOUR HEAD. YOU ARE AMAZING! AND BRILLIANT! EVERYONE THINKS YOU'RE THE BEST!

Or picture naked people. Whatever works.

REMEMBER THAT 80% OF YOUR AUDIENCE IS PROBABLY TEXTING ABOUT LAST NIGHT'S TERRIBLE BLIND DATE OR WONDERING WHETHER THE DELI HAS EGG SALAD TODAY.

P.S. According to the *Wall Street Journal*, people who suffer the most from public speaking anxiety also care the most about their careers. Which might not "help," per se, but is a nice thing to know.

groovy

THERAPY TIME!
(A CHEAT SHEET TO HELP PICK THE RIGHT PROFESSIONAL FOR YOU)

When it comes to anxiety, the answer to "Should I ask for help?" is virtually always "Yes, of course you should." And if anyone makes you feel shitty about this, please remember that that person is shitty, not you.

In any case, it's important to remember that all forms of therapy have their own idiosyncrasies. The trick is choosing the approach that fits best with your particular personality.

Psychoanalysis

Uncover your unconscious motivations and release your repressed feelings, mainly as they pertain to genitalia. If you like lying down and staring at the ceiling while talking, this may be the right kind of therapy for you.

Art Therapy

Use creative expression to release your emotional garbage, feel better, and reveal things about yourself. Did you just paint a cloud? What does it mean? Is it covering the sun? OMG you're super sad.

Clinical Psychiatry

Talk about your many, many feelings, and then receive many, many drugs (maybe).

Cognitive Behavioral Therapy

Apply practical solutions to your daily life in order to feel better. Unlike Freudian analysts, who let you blame your mom, CBT therapists think you should just stop calling her so much.

One of Those Texting Services

For a small fee, go ahead and text a (licensed? Maybe!) professional whenever you want.

Journal:

Types of Therapy I've Tried:

_____ Worked ☐ Didn't work ☐

_____ Worked ☐ Didn't work ☐

_____ Worked ☐ Didn't work ☐

Drugs I've Tried:

_____ Worked ☐ Didn't work ☐

_____ Worked ☐ Didn't work ☐

_____ Worked ☐ Didn't work ☐

PARTY ANIMAL

Hand this page over to a partner, who will prompt you for each blank, then read your epic creation out loud.

When I opened the invitation for _____, I was immediately
 event

_____. I mean, who wouldn't want to _____ with
 emotion verb

_____?!
 acquaintance

When I arrived, I immediately felt _____ and looked around for
 emotion

_____, _____, or a/an _____ I could hang
 same acquaintance other acquaintance animal

out with. Unfortunately, the only person I saw who I knew was _____, who
 name of ex

was standing over by the _____ and drinking as much _____
 noun liquid

as possible.

"_____," I said. "You look _____."
 greeting adjective

"You look pretty _____ yourself," he/she said.
 adjective

And then we talked about _____, and it wasn't _____ at all.
 plural noun adjective

When he/she wandered off, I decided to _____ by the _____,
 verb piece of furniture

but no one else seemed to want to, so I just started _____ instead. I
 verb ending in -ing

was pretty _____ and wanted to _____, so I began to
 emotion verb

put on my _____ . . . and then I saw it: a _____, sitting
 article of clothing baby animal

right there next to the _____. And that's when I knew it: This party was
 noun

going to be _____ as a _____ _____ a
 adjective noun verb ending in -ing

_____.
 noun

22

WE GOT YOU A PLANT

According to some wellness gurus, one technique you can use to make yourself happier is to (1) picture a succulent, then (2) picture a dream of yours, and finally (3) picture your dream sitting on top of your succulent.

Go ahead and put your dream on this succulent.

COLOR IN THE TOXIC SOCIAL MEDIA OFFENDERS

Social media has given us an intimate peek into the lives of total strangers, which would be interesting if most of them weren't exactly the same.

You definitely know these people, or at least follow them online. Color in their posts while taking solace in the knowledge that IT'S ALL A LIE.

The Spiritual Leader

DON'T JUST TALK ABOUT STUFF. DO THINGS.

♡ ◯ ↱

Aren't you glad your aunt Lydia reminded you that you did not wake up today to be mediocre? Doesn't that make you feel so much better?!

The Hashtag Enthusiast

♡ ◯ ↱

#bliss #instagood #instayum #thatsprecious #solovely #photooftheday #outfitoftheday #instaoftheday

The Food Photographer

Unless they will be personally delivering that stack of brownies to your house, you do not need to see it.

The Person Doing This

Draw your own!

Journal:

I shamefully admit that I have, at one point or another, posted (circle all that apply):

a) wayyyy too many pics of my pet, but whatever, he/she is adorable and people need to know that
b) a motivational quote, because it just felt so right-on
c) my dinner plate (after I finished eating because I forgot to take a pic before I started)
d) my feet, which of course I Photoshopped first to get rid of my bunion
e) my hand pointing to something
f) a sunset that, in retrospect, looked like every other sunset everywhere

I would never admit it to anyone but my activity book, but I totally follow:
a) Justin Bieber
b) one or more Kardashians
c) one or more exes
d) one or more elementary school frenemies
e) all of the above, because life is too short and joy is joy

THE SOCIAL MEDIA
HELLSCAPE

Welcome to the New World: one where you're constantly confronted with images of people who have much, much better lives than you. They're vacationing! And eating healthy things! And have piles of unrelated-yet-aesthetically-pleasing items arranged on their (white, artfully unmade) beds, just sitting there all chic and waiting to be photographed.

Find the other things that are obviously on your feed right this very moment. (Bonus: Open up Instagram and circle the first five you see—it's like bingo for the snarky.)

ARTFUL LATTE
HASHTAG LOVEMYLIFE
TOMORROW IS A NEW
 DAY
WEIGHT-LOSS UPDATE
AVOCADO TOAST
MAGA
THAT CAT AGAIN
ACAI BOWL
ADORABLE ANIMAL
 FILTER
DUCK-FACE POSE
LOOK HOW CUTE MY
 SHOES ARE

FEET IN OCEAN
FEET IN SAND
FEET IN BATHTUB
FEET BEING
 PEDICURED
OOTD
NON-ASPIRATIONAL
 FOOD
PRODUCT PLACEMENT
SKINNY-ARM POSE
BABY DOING ANYTHING
AIRPLANE WING
JUST A PRETTY FLOWER

```
X D A R N Q S B T E M X K O J R B Z E F A S H A H E D O N D Q F T C C H L O B L
F U D H V N Z S I O D D P U L C D C J D V B I T G C O P B B Q Y D U W I T B Y A S V
D C U P N U C E O Q M A L D B I S U T A N O M J R G O V E B D N M K P T X T B Y H
T K F L J I F M G L X O Z B H S S L M H G G V B P S F M K E I S U X Q S I W I Z
G F I J N Q J B W M A K R F H T B J N Y J S Y V K L S B T G X N G D B W I D O Z
W A U N K P T O M F H Q I R A Q L X J E A Y H M I R A G M T G N C A G D Q M O Z
A C Y W A F B N A E H A I P O J X P V V M J J T Z D N M M D C Q F U Z R C X I F
L P J T A J O S A W N E T L H I I S R Z R G V C T Y I Q Z H A V J H R B L B G A
H O J C W V K K S R T G G J I R P S O V Q U D P Q H T I Y T R L H E H B D Q A K
A S A R W Z A L R T O P F Z P D O R A H E P I X W F A U Y R C H Y L X Y D O N K
B E E R U Z M O Y V D P E L P C Z F E N F L U P X E R K K K Y N D M G D W U Y Z
E D Y D G P U F X I L B A V I N G M E T E B N A U T I A V O C A D O T O A S T E
K Y O D N L L I Y W R N M P A B R A A K L W E T A D P U S S O L T H G I E W H C
E R A S E O H S Y M E T U C W O H K O O L I D S H T S W K L Y Q G V L L E B I R A
D T Y B W I O T N W E T T A L L U F T R A S F A M A A X E K L G M R L S S Q N R A V
I K N E A M F E I U H T V Y Q K C V X E N O B L Y A N C Q U C I B N O E N K G V
Q J R E T I Z N O O G B X W J X H M S N O K U V A E O I E M F O L P Y G J L A A
J T K M M H G N F O E V F A X X O L J I C R K K L M N G H G T U M E B F J D M E
Y C P C O E A F T L J Z U L F I K U Y W V X Y K X I L A C B R R Q R N Z P H E I
V Q R Z W X C T H A S T A G L O V E M Y L I F E E W N H T A M O O Y F S F V C
U D A C K S E A C Z T T D E H E E P R E P B C T R T N E A Y O A O A Q H H D G N
R H K N R N O V L A U J I K P M L R E Z Q Q G E D Y X U N E T A Z B J T X Y G E
Z D F H R B A W P P T Z D B R H Z G A W R G X E L F E N B R L A O L X H E V N D
O N D L I U K E F O T A H T V A B L D E S F R W F D I N J T V B A L U Z D U Z Y
U A I B X T P C C M R C G D E N Y M B I N U E B K K D C F J F A A D X C A I Y K
J S V A P H P V E O A W U A R U X M I S C V T P S X J B E Z Y E M R G Z Y Y V H
X N Q H S T O X B C N Q K D I Q G Q L I T M Q M Q F O U Y V F O Q W O B F C J B
V I S O Q A W M S B J I B G O N A Z D V F N S M W T N S P S K A A O Q D C L N J
F T K Z G B X Q V P X E T X L R J E V Z J K R U Y Q C J A H U O U H H Y A J T M
U E Q S Q N O C B I I J T E C S P L G X W P E B W M J K G D A R Y U D E E L H M
Y E Z M Z I O H L V K Z Y V E G C A R H U T D E T G S K E S J Q H I C A P F C K
Q F S U T T Q A K S Q S P O N F W Y N J G Q U G J D H G H S M Z G V T X V F B
D P N W R E F I Q S A K F I X W R Z C C V G J F X E M W J T F H D K N S F N I B
H J Z A S E C V L T K B E R X Y R H T I Y J W F Z N Y S M L J B U T W L J A J F
G X K G X F U K P I N B K H J J D O H J B I Q U Y Q E X L R M A G X G U B J H P
F M N L L H U J X C O T D H K W C Q U T Q M A G A S Z M X A B H K A Q D M V B H X
J O V Q P Y D D E O D V U E L U H L N J V P E I A S X B K G F N C C C K J P S Z
S X Z D G D X W E Y W T Q B M G X K J A M F E X F C U K U N K L J W E S Z X Q Z
M Z C S K C G F Z O S G D R N C X U H T B B Q L H Z F U Y V I Z J B N X D A W G
```

Pair your favorite adjective with your favorite noun to find the perfect social handle.

Salient	Dragon
Withering	Gallimaufry
Fecund	Alfalfa
Pendulous	Vortex
Insidious	Waffle
Redolent	Wiggler
Turgid	Piglet
Comely	Firefighter
Meretricious	Spaghetti

TEXTS YOU DON'T WANT TO GET

Ah, the sweet, sweet ding of the text notification, alerting you to the fact that somewhere out there, someone is thinking of you. Maybe even thinking something nice! Maybe they want to hang out with you!

But it's probably just someone telling you that you forgot to do something important. Such as:

- People at work who you didn't give your number to. On a Saturday.
- A relative who wants to talk about your life choices
- A friend from fourth grade who you haven't talked to in three years wanting to "get together and catch up!"
- Flash sale updates from the organic matcha shop in Hoboken you shopped at once, three years ago
- Lists of things to buy
- Lists of things to do
- Lists of ways in which you are inadequate
- A text from _____ letting you know that _____. (UGH.)

CUT OUT THESE CELL PHONES AND DESTROY THEM ⟶

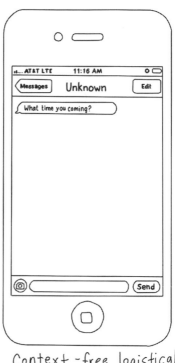

Context-free logistical questions from unknown numbers

Anything related to the DMV

your own drunk texts the next day

Dick pics

Low-balance alerts

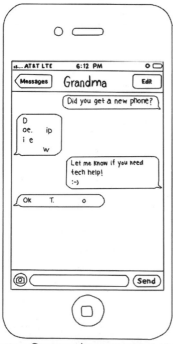

Grandparents

PAGE INTENTIONALLY LEFT BLANK

PEOPLE WHO ALSO HAVE HPV!

Are you alive? Have you ever had sex? Congratulations, there is a 74% chance you have HPV! Don't feel bad. Unscramble the names of people who (probably) have it, too.*

SHERRY DEPRIVED REFLECTIONS

SOUR BOYS

MERE RATTLESNAKE ORGY REEL

ESTUARY PORN**

HAM KNOTS

CLARO

*We're super nice! Don't sue us!
**Sorry

Answers: Fresh Direct Delivery Person, Your Boss, Solar Energy Telemarketer, Your Parents, Tom Hanks, Carol

DECORATE THESE PARTY BALLOONS
...BECAUSE WHY NOT?

anxiety check-in

Today is __/__/___.

I'm feeling: _____

Some people I love: _____

Some places I love: _____

Some things I love doing: _____

Something I'm looking forward to: _____

Something I can look up and see right this very second that makes me happy: _____

When I step back and take a good, hard look at it . . . my life is pretty damn beautiful.

THINGS YOU SHOULD'VE SAID YEARS AGO THAT YOU CAN SAY NEXT TIME

Are you one of those folks whose mouth specializes in forming spectacularly awkward and/or inappropriate responses? And then five hours later, your brain finally catches up and tells your mouth what it should have said instead, except you can't, because it's five hours later and just randomly yelling something would be weird? Say it here instead.

TO THE BEST BUY SALESPERSON

TO YOUR MOTHER-IN-LAW

"Crazy story: Our next-door neighbor just bought goats, but now she has to travel to Rio for the entire month of November for this antique doll–refinishing convention and anyway, she asked me to feed her goats while she's gone, because if nobody feeds the goats they'll die. Which would be so sad. So, long story short, it looks like we won't be able to join for Thanksgiving this year."

TO YOUR BOSS

ACTUALLY, YES. A NEW DESK CHAIR WOULD BE GREAT.

PRACTICE! FILL IN THE BLANKS BELOW.

TEXT MESSAGE FROM _____ :"IT'S BEEN A GREAT FOUR YEARS, BUT I JUST DON'T FEEL READY FOR A COMMITMENT RIGHT NOW."

My response: _____

THE PERSON YOU'VE MET TWENTY-THREE TIMES WHO SAYS, "OH HEY! SO NICE TO MEET YOU."

My response: _____

WHAT TO DO WHEN SOMEONE YOU LOVE LETS YOU DOWN

1. Cry.
2. Eat pasta, or sugar, or pasta with sugar sprinkled on top of it.
3. Cry really hard.
4. Talk about it with someone.
5. Be nice to yourself.
6. Take it easy.
7. Let it go.

Draw a picture of yourself on this yacht, which the person who let you down is not invited on.

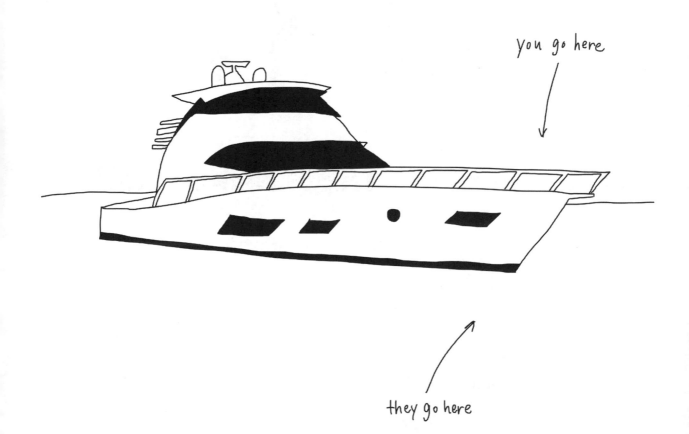

you go here

they go here

GRATITUDE LIST

One of the best tools in an anxious or depressed person's toolbox (or anyone's, really) is a gratitude list. We realize that the last thing you want to do when you feel insane/scared/sad is sit down and think about what you're grateful for, but unfortunately (fortunately!), it works.

Today I'm grateful for: _____

I'M ALSO GRATEFUL FOR . . .

This person, who helped me when they didn't have to: _____

This person, who I had the opportunity to help: _____

This thing about my home: _____

This thing about my family: _____

This thing about myself: _____

OTHER BROKE PEOPLE WHO ARE COOL

(Lack of) money got you down? You're in good company! 100% of people have financial anxiety, including the top 1%, who are extremely worried that their beloved aunt Apple's inheritance will decrease by the same amount they need for that extra Lamborghini due to a toxic—i.e., totally reasonable—estate tax.

For those of us who don't use our wine cellars to store bars of solid gold (but only because we don't have wine cellars), look at all these fab people who also worship at the altar of Sallie Mae!

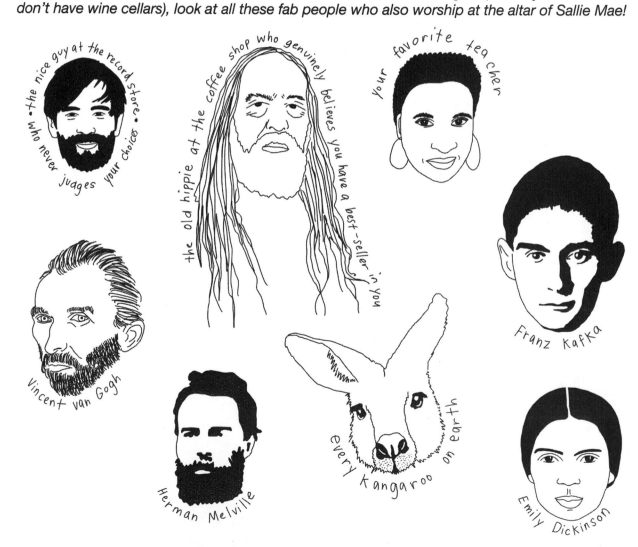

the nice guy at the record store who never judges your choices

the old hippie at the coffee shop who genuinely believes you have a best-seller in you

your favorite teacher

Vincent van Gogh

Franz Kafka

Herman Melville

every kangaroo on earth

Emily Dickinson

WHAT ARE PEOPLE IN FIRST CLASS THINKING?

Ever walked through first class on your way to coach? Maybe every single time you've been on a plane? Wonder what those smug, first-to-board, first-to-exit, champagne-sipping, attitude-having, of-course-there's-room-for-my-five-carry-ons people are thinking about you? Let it out.

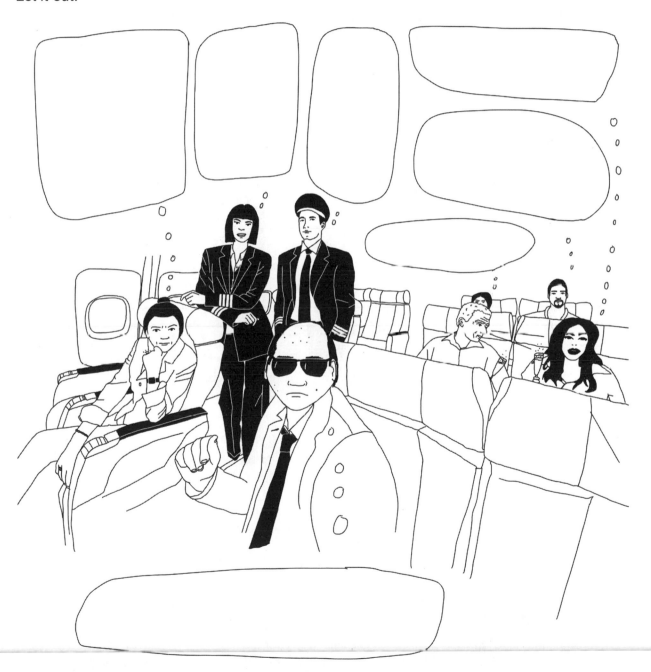

MATCH THE SONG YOU SHOULD NOT LISTEN TO WITH ITS ARTIST

We anxious people should throw our headphones out the window the second the first notes from these songs hit our eardrums.

"The Man Comes Around"
"The Day the World Went Away"
"Earth Died Screaming"
"Bad Moon Rising"
"Black Hole Sun"
"When the World Ends"
"Eve of Destruction"
"Wooden Ships"
"The End"
"Talkin' World War III Blues"
"The Weeping Song"
"Epitaph"
"Sinnerman"
"Till the World Ends"

Soundgarden
Dave Matthews Band
Nina Simone
Creedence Clearwater Revival
Nick Cave & the Bad Seeds
Crosby, Stills & Nash
The Doors
Britney Spears
Tom Waits
King Crimson
Nine Inch Nails
Barry McGuire
Johnny Cash
Bob Dylan

THESE SONGS ARE ALSO BANNED:

Answers: "The Man Comes Around" (Johnny Cash), "The Day the World Went Away" (Nine Inch Nails), "Earth Died Screaming" (Tom Waits), "Bad Moon Rising" (Creedence Clearwater Revival), "Black Hole Sun" (Soundgarden), "When the World Ends" (Dave Matthews Band), "Eve of Destruction" (Barry McGuire), "Wooden Ships" (Crosby, Stills & Nash), "The End" (The Doors), "Talkin' World War III Blues" (Bob Dylan), "The Weeping Song" (Nick Cave & the Bad Seeds), "Epitaph" (King Crimson), "Sinnerman" (Nina Simone), "Till the World Ends" (Britney Spears)

REASONS WHY HAVING ANXIETY IS A GOOD THING

We all know that being an anxious person can sometimes be less than fun, but other times it is pretty awesome—even lifesaving!

Some reasons why you're lucky:

- You're already emotionally prepared for an alien takeover.
- . . . and bird ambushes.
- You are less likely to expire from having ignored that funny little bump.
- If your goal is to be more peaceful and chill and "hey, man, whatever happens, happens" and you live in certain states, your diagnosis will score you a prescription for weed.
- If you let your guard down, everything will fall apart, so you're doing the universe a favor. It's like being a superhero kind of.
- You will go home to double-check that you turned off the stove (and sure, you may not have cooked anything in two years, but on the off chance you did last night and just forgot, you saved your house from burning down. You're welcome, neighbors).
- Everyone thought Sarah Connor was crazy, but you know what she was? RIGHT.

— I'll be back
(as you know)

TOP FIVE

WHAT ARE YOUR BIGGEST, TOTALLY RATIONAL FEARS?

bacterias

meeting new people

Pinhead

gossip

1. _____

2. _____

3. _____

4. _____

5. _____

MATCH THE PHOBIA TO THE FEAR

Everyone's got a phobia. Maybe they're scared of the dark, or of being trapped in an elevator, or of spiders. You know what those phobias are? AMATEUR HOUR. If you want to impress anyone, you'll have to freak out when you see belly buttons.

Match the name of the phobia to the locus of its fear.

1. Trypophobia
2. Globophobia
3. Aibohphobia
4. Papaphobia
5. Sesquipedalophobia
6. Heliophobia
7. Ablutophobia
8. Triskaidekaphobia
9. Nomophobia
10. Optophobia
11. Coulrophobia
12. Somniphobia
13. Omphalophobia
14. Phobophobia
15. Ishicascadiggaphobia
16. Arachibutyrophobia

A. Fear of peanut butter sticking in your mouth
B. Fear of having a phobia
C. Fear of long words
D. Fear of bathing
E. Fear of opening your eyes
F. Fear of not having your mobile phone
G. Fear of elbows
H. Fear of sunlight
I. Fear of clowns
J. Fear of falling asleep
K. Fear of belly buttons*
L. Fear of the pope
M. Fear of balloons
N. Fear of holes
O. Fear of the number 13
P. Fear of palindromes

If you have this one, you can consider yourself a queen, because so does Oprah.

Bonus question: Which fear(s) is/are fake? _____

Answers: You can tell that aibohphobia—the fear of palindromes—is fake because (1) palindromes aren't scary and (2) the name of the phobia is a palindrome itself. And even though you'll see arachibutyrophobia on lots of "weird phobias" lists, it was made up for a Peanuts comic strip and just sort of caught on.

1. N, 2. M, 3. P, 4. L, 5. C, 6. H, 7. D, 8. O, 9. F, 10. E, 11. I, 12. J, 13. K, 14. B, 15. G, 16. A

FACTS TO MAKE YOU FEEL BETTER

- Some parts of the ozone layer are repairing themselves.
- Public libraries exist.
- The back slime on a certain species of frog literally makes the flu virus explode. And removing it doesn't even hurt the frog!
- You can find the delicious Australian cookies called Tim Tams in America now.
- We are thisclose to wiping out the Guinea worm parasite. Guinea worm parasites are three-foot-long worms that look like spaghetti noodles and erupt through the surface of their host's skin via incredibly painful blisters, so this is excellent news.
- There is an entire YouTube channel devoted to Bob Ross.

- In 2017 a group of high school students in Boca Raton, Florida, started a club to make sure that no one had to eat lunch alone.
- We've started to be able to detect gravitational waves in the universe, which basically means we can HEAR OTHER DIMENSIONS. (Maybe. Super cool, regardless.)
- In Grenoble, France, all the outdoor advertisements were replaced with trees.
- Scientists are developing a graphene-based sieve that turns seawater into drinking water.
- Hyperloop transportation systems are happening all over the world. Soon, you'll be able to shuttle from New York City to Washington, D.C., in twenty-nine minutes. That means you can be in another state while your friend is still waiting for the G train to show up.
- Scientists recently found a brand-new type of aurora, and they named it Steve.

FIVE SPECIES NOT AT RISK FOR EXTINCTION!

THE WHITE-TAILED DEER, aka Bambi, is alive and well, scurrying about North America eating things like leaves, cacti, and the spare ear of corn. They mostly live in Texas, where people like to hunt them. Let's not talk about that last part.

DONKEY DUNG is the actual name of a type of sea cucumber, which makes sense if you look at one. It's a warty, twenty-inch brown pile of wholly non-extinct life. Some people buy it (with money!) and eat it.

DUSKY FRUIT BATS live in caves and eat forest fruits, not human souls.

THE FRILLED SHARK, though vaguely terrifying, promises not to appear on a stamp anytime soon. Also, its needle teeth are mostly used on jellyfish and not human flesh, so that's nice.

THE AARDVARK uses its long snout to sniff out food, aka bugs. They are nocturnal, and will be hanging around to grace the first page of the dictionary for years to come. Isn't that comforting?

CONDITIONS FOR WHICH "FATIGUE" IS A SYMPTOM

Feeling tired? Locate a few of the many (oh, so many) conditions from which you might be suffering.

EMPLOYMENT
CHILDREN
NO MORE DIET COKE
NARCOLEPSY
CANCER
MONONUCLEOSIS
IRRITABLE BOWEL
 SYNDROME
PREGNANCY
MALARIA
TOO MUCH *AMERICAN HORROR STORY*
CAROL IN THE NEXT
 CUBICLE WON'T STOP
 TALKING
CAT SLEEPING ON YOUR
 HEAD
YOUR PERIOD
DEPRESSION
MASSIVE BLOOD LOSS

MOTION SICKNESS
CAROL'S DATE LAST
 NIGHT WAS THE
 WORST
NOT ENOUGH COFFEE
TOO MUCH COFFEE
SHOCK
HUNGER
THIRST
HANGOVER
CAROL'S COUSIN WORE
 WHITE TO A WEDDING
CAROL JUST CAN'T
RATTLESNAKE BITE
TOO MUCH SLEEP
TOO LITTLE SLEEP
EXACTLY THE RIGHT
 AMOUNT OF SLEEP
 BUT LIFE IS HARD YO
RESPONSIBILITY

```
M R A M Z O M I W Q J B O S V S T P N F M Q W U T H F A B I L N H V Q B V D T F
H L J G D K L H D I H E R R P J U O J B X V Z O S K F E A S W Y E B L U A H D X F S T U W T N E M
G J Y E O T S V W E F N B M D O R S S E E L H L T N U A C T S E O O O H E A N A D G E M Y L G H
O X N K I E I C G X P B Y C A K T V A Y Y Z Q X H C C K K E H P U N L R I R A G D S O T M N X P
N K P B K Z B O V R U H C I U I B E Y Y F J C R M A U I X M R K K H G S G A X O P T M O N V P B
V W Q V G L R E J Z Z U E B L Y Y K F J C R M A E Q L P R Q O T I E S Z L X E B R I B O N U H K F
L H U G N I J T E C Q D O E E N V A B Z Q X W E I U A V X F A P O Q A G L N E E T T H Q X G E N U A
Z Z P N X D E X O G L T O E Z Z Q T Z S G V D E V B U Y C S G M S N C F K J F T L S E E P
M L L Z R E K S S I R C P T N T T N L X R O D S C A I W N I A J Z Z B Z V F R T O L
L H N C W X S J A I V M R N N T E A P E M L K Y S P L Q W R Y Q J S C F W T O E
N Y Y X A J O N A P H R I T O G A W Z C O H M N Q H T U B I E N Z X L L H S I S P A
Q Z F W T N L G M E P S T F Q F X E Q O A F I Y Y R G R Y W Y J I F G S F F S I N
K Z K N E R E L C G B W J C G M L A C P C T E H I L F O U C Z Z T L W L V N H D
Z L N K I D F E F E N Q N A B O F O T X A C M I G A T A S Z Y U I U E T U C J O V S L O
L J J R Y N E V T F P G C K Y Y N X R B S I M F W A U F E R E V O G N A H K B R W I E U O W
J E O R E V R A H S I E F I L T U B P E E L S F O T N U O M A T H G I R E H T T S O U R
O X O X K G S H S V Q C E D H T T O O L I T T L E S L E E P B H R J T R A Z P H
P J Z W X A D U U G S H M T V D M J U C R U M O K N U K J T M L C T U E O U R H E A
J Y S E Q I J Q T Z E N X O S Q E F F C H M N O L P T O N T C B P C K H K K X Z W A Y D B E R U
R X B L U Z Q O Z E N X O I K G W J K O W P R V I T O G E B W N A I Y O M I E J H R Z W R H T G X
W O E M C S K I F D S A L P I T G F S D V Y O U R P E R I O D C E I G M L E L T W R J U D E H
Q Z V S K I A M U C H A M H E N A I C A N H O R Z H E T E P C F E F R J J N O
Z E N K Q O T I J T U T N K A X X A C P G U J B N U J Q J O P R I T J J N O Q
O E O P G Y R A U G P G E M V Q U T K S H N R Q A Q S I S M R S J A U D O H Q
P J C C R S H R Y V G G E M P M Z B K A U N Q S T S W S Z S A A Y K M I F K L Y
```

GREAT WRITERS WITH ANXIETY, BESIDES YOU

You're in good company: All the world's best writers and thinkers also had anxiety of one kind or another.

leo tolstoy

ezra pound

amy tan

sylvia plath

abe lincoln

j.k. rowling

virginia woolf

WRITE A BRILLIANT STORY!
(WHAT, LIKE IT'S HARD?)

Now that we've established you're meant to be an incredibly rich, famous, and successful author . . . have you decided what you're going to write about? No? We're here to help.

Use the table below to figure out the topic of your bestseller.

	FIRST LETTER OF YOUR FIRST NAME	FIRST LETTER OF THE TITLE OF YOUR FAVORITE BOOK	FIRST LETTER OF YOUR LAST NAME
A	An African elephant	Barfs	At Walmart.
B	A lazy pirate, unmotivated by greed	Finds true love	In a slaughterhouse, reeking of death.
C	A busty woman with nothing to lose	Starts a kangaroo-meat business	At an apple farm, green and fresh from the morning sun.
D	A doe-eyed orphan with an egg in his pocket	Eats endless spaghetti	On a glistening skyscraper wet with dew.
E	A young princess who's been languishing in a tower	Furiously masturbates	Beside a new tractor trailer, receipt still dangling from the rear.
F	A small child in dirty clothes	Writes poetry	At a tropical oasis replete with pool noodles.
G	A horse-loving teenage girl	Pens a tragic opera about nine children stuck	Inside an oven.
H	A giant bowl of meaty spaghetti	Learns to use the potty	At Harvard.
I	A beautiful Russian mail-order groom	Fights an angry alligator	At Pinkberry.
J	An enormous lava monster from Mars	Has gender confirmation surgery	Inside Scientology headquarters.

K	A fifty-year-old bachelor with love only for golf	Hires a gang of unruly orphans to sell newspapers	Outside a wealthy veterinary clinic in Tuscaloosa.
L	A darkness that can't be seen, only felt	Becomes a legendary archer	At home, in the basement, shackled to a pipe.
M	An aged lesbian widow	Gives birth to septuplets	Front row at a Sonic Youth concert.
N	A vegan who can't drive	Discovers the corpse of Roberto Bolaño	Inside a clockmaker's tiny Swiss shop.
O	A memoirist with amnesia	Finds meaning in a Dumpster	Inside a tent in the deep, dark woods.
P	An alcoholic on a desert island	Sells their record collection for ten million dollars and travels	Under the sea (under the sea).
Q	A blind private eye	Gives everything up for Jesus and retires	While listening to *Freakonomics Radio*.
R	A lustful hooker with a taste for blood	Gets plastic surgery to appear more treelike	Aboard a great ship somewhere in the middle of the Arabian Sea.
S	A feminist spiritual advisor	Consumes human flesh	Under the Tuscan sun.
T	A white male novelist who feels oppressed	Learns the art of bonsai	At a five-star restaurant.
U	A silent nun raised in the mountains of Utah	Compliments an octopus on her luxurious limbs	In a blackout.
V	A great king with Alzheimer's	Steals his/her best friend's firstborn	At a chicken farm somewhere in Ohio.
W	A homesick single mother far from home	Lives a double life	In a decrepit nineteenth-century insane asylum.
X	A nutritionist hell-bent on taking down "big soda"	Listens to Dinosaur Jr. and cries	During the president's State of the Union Address.
Y	A Victorian washerwoman	Confronts his/her mother's secret lover	While wiping the sweat from Britney Spears's aged brow.
Z	An unemployed, never-nude zookeeper	Has sex with Fabio	In his/her daughter's first-grade classroom.

FIRE YOUR BODY PARTS

We can all agree that the primary function of eyeballs is to see, but as we get older, they get lazy and grumpy and forget what they're supposed to be doing, which is helping you not walk into things and also read books and stuff. Don't you wish you could fire your old eyeballs and replace them with younger, more tech-savvy models that will do more work for less money? Wouldn't it feel swell to cross "the slow and inevitable decay of my physical self" off the list of things keeping you up at night?

Circle every body part that's doing a crappy job right now and really needs to do much better if they want to keep the boss happy.

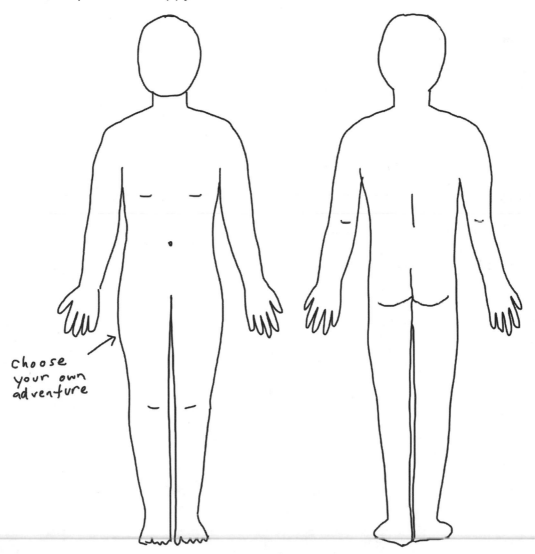

choose your own adventure

OBSCURE DISEASES YOU PROBABLY DON'T HAVE

ALICE IN WONDERLAND SYNDROME

Ever done acid? It's like that. Generally the by-product of a migraine, a brain tumor, excessive use of psychoactive drugs, or a severe lack of sleep, the syndrome causes sufferers to perceive objects as much smaller or larger than they are, and often feel as though they themselves are growing or shrinking. Lewis Carroll allegedly based Alice's experiences in *Alice's Adventures in Wonderland* on his own perceptions of the world, hence the syndrome's name.

COTARD DELUSION

This disorder is characterized by the belief that one is dead, which sounds terrible enough, but sufferers may also feel that they are putrefying, have lost their blood and/or organs, or do not exist at all. Paradoxically, those with Cotard delusion also frequently suffer from delusions of immortality. In one famous case, a nineteenth-century Frenchwoman, Mademoiselle X, insisted that she was missing parts of her body and had been condemned to eternal damnation—so therefore she did not need to eat. She died of starvation.

EXPLODING HEAD SYNDROME

Despite having the most terrifying name imaginable, exploding head syndrome does not result in actual head explosions. Instead, sufferers experience loud (but imaginary) sounds, such as bombs going off, cymbals crashing, or gunshots, often while falling asleep or waking up. Fun fact: Conspiracy theorists believe that EHS is the result of a "direct energy attack" on the brain. (Spoiler: It's not.)

JUMPING FRENCHMEN OF MAINE

Perhaps the single most specific disorder of all time, this exaggerated startle response afflicted a group of French-Canadian lumberjacks living in rural northern Maine during the nineteenth century. No definitive cause for the jumping was ever determined, but some have theorized that the sufferers received positive feedback from their small community due to the "entertainment value" associated with their reactions. This likely tells you more about life in nineteenth century rural Maine than anything else.

HAIRY TONGUE

This extremely unattractive buildup of cells and microorganisms on the surface of the tongue is generally found in very heavy smokers with very poor dental hygiene. On the plus side, the cure is, basically, "go brush your teeth, you cave person." (Warning: Do not google. It looks exactly like you think it looks, and having a rock-solid mental image of hairy tongue will not help you sleep at night.)

TOP FIVE

THINGS THAT ARE SUPPOSED TO BE CALMING BUT ARE NOT

one of *those* signs

eye vegetables

stacks of rocks

1. _____

2. _____

3. _____

4. _____

5. _____

COLOR IN THE WAYS YOU'RE UNLIKELY TO DIE

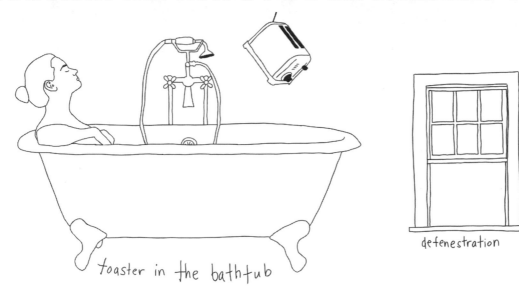

toaster in the bathtub

defenestration

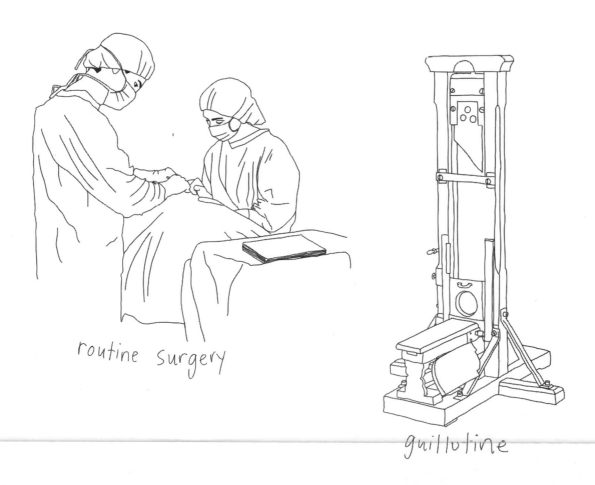

routine surgery

guillotine

THE ANXIETY DIET

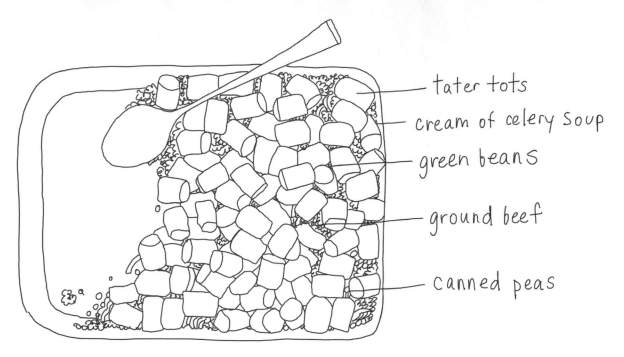

- tater tots
- cream of celery soup
- green beans
- ground beef
- canned peas

Mom's famous Hot Dish

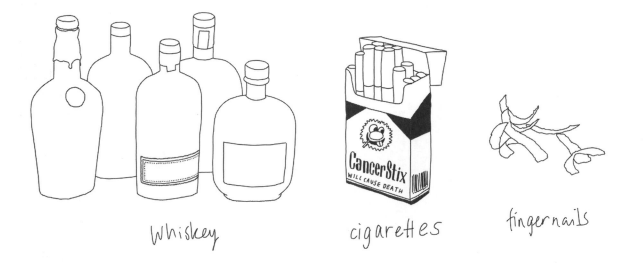

Whiskey

cigarettes

fingernails

RIDE THE SUBWAY WITHOUT TOUCHING ANYONE!

NOTHING GETS THOSE GERMAPHOBE JUICES GOING QUITE LIKE THE PROSPECT OF A NICE LONG RIDE INSIDE A STEEL COFFIN ALONGSIDE SOMEONE WHO HAS PEED HIMSELF, CHILDREN WHO ARE CLEARLY SUFFERING FROM THE BUBONIC PLAGUE, AND THE OCCASIONAL FLASH MOB.

START

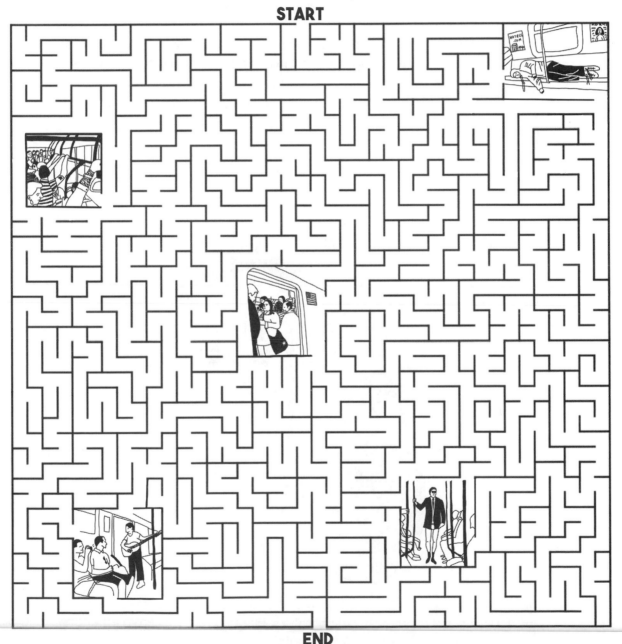

END

FIVE ASSHOLES EVERYONE KNOWS...
AT THE MOVIES!

Remember when you were a kid, and going to the movies was like mainlining a speedball of Jujubes, Pixar, and bliss? Now it's about assholes. In front of you, behind you, checking their text messages right next to you.

1. The asshole ahead of you in the ticket line who asks the cashier sixteen highly specific questions about things he might know the answers to, were he Wikipedia.

2. The asshole in front of you who won't stop moving his giant head, thereby requiring you to move your normal-sized head, thereby setting off a chain of events wherein an endless line of people all have to keep moving their heads forever.

3. The asshole who saved a seat for his jacket because he wants to sit alone.
(Note: We are all this asshole.)

4. The asshole chewing Milk Duds so loudly that she sounds like a lion separating the limbs of fresh kill for her young.

5. The asshole who leaves all her garbage on the floor after the movie ends for the grossly underpaid staff to clean up, because clearly she was raised in a barn.

anxiety check-in

Today is: __/__/____

On a scale of 1 to 10, my anxiety is a _____ today.

I'd be more anxious right now if I were:
 a) reading the news
 b) at a carnival riding the Sizzler and trying not to vomit
 c) doing my taxes
 d) giving birth
 e) all of the above

I'd be less anxious if I were:
 a) relaxing in an herbal bath
 b) abusing one or more substances
 c) eating a fifth slice of pizza
 d) living in a gated community where there are no people, only dogs
 e) all of the above sound perfect, thank you

The thing I'm most worried about today is _____, but
this probably won't happen because _____. But if it
did happen, everything would eventually be okay, because _____
_____. WHEW.

The thing that makes me feel better is:
 a) calculating statistical probabilities of Very Bad Things happening
 b) exercising
 c) calling my mom/best friend/psychic hotline
 d) watching YouTube videos of old people twerking
 e) all of the above, minus exercising

I'm obviously extremely busy and important but promise to do the following today anyway (check all that apply):
☐ Make a hot cup of tea and sit and drink the entire thing without looking at my phone.
☐ Eat a delicious, healthy meal because I deserve better than crackers and half a container of leftover Chinese takeout.
☐ Read an actual book with actual pages made of actual paper for twenty minutes before bed.
☐ Put fancy oil in a diffuser and pretend I'm in a spa (and feel smug because I didn't have to pay $200 plus tips to experience lavender-scented air).
☐ Sit in a quiet room for five minutes and lie to my roommates/partner/kids/boss so they don't know where to find me.

ZEN MANTRAS FOR THE ANXIOUSLY INCLINED

PANICKING INSIDE

A Zen mantra is just a bunch of words you say over and over again until you accept the true nature of reality and relax into the existential hellscape that is your life.

Repeating the phrases below can help you let go of your attachment to the things that cause worry and strife in your life, such as your job, your family, your friends, your relationship, and money.

I vow to love, respect and treasure all of earth's creations. If there were a fire, I would save my cat Raffles, my roommate Jen, and that leftover lasagna because it was excellent. In that order. I think.

I deserve happiness. It is not my fault that the world is conspiring to remove any semblance of joy from my life via apartment rental prices, and the fact that Ryan Seacrest both exists and is richer than God.

I don't have to be perfect.
Everybody's pubic hairs peek out of their bathing suit once in a while.

I am the one who decides whether or not to be stressed.
The fact that I always decide "yes, be stressed" means that I am consistent.

It's not the end of the world.
In like ninety-nine out of a hundred situations.

MEDITATIONS YOU SHOULD TRY

In theory, meditation is wonderful. In reality, it is just one more goddamn thing you feel guilty about not doing as much as you should (or ever). In case you'd like to give it a(nother) go, here are some ways to achieve inner peace. Kind of.

1. Close your eyes. Focus on your breathing. Inhale deeply into your belly. Exhale slowly through your mouth. Remember how you have that meeting tomorrow? Don't think about that. Also don't think about how your hot coworker asked you how you were the other day and you said, "I have to go to the bathroom" and turned maroon. Remember when you thought Maroon 5 was good? Stop thinking. Inhale. God, you are so bad at this. Exhale.
2. Download the $4.99-per-month app that you will use four times and then delete but not cancel. Commit to meditating for ten minutes per day. Do this religiously for four days. Buy a prayer mat and a Pema Chödrön book. Buy a Himalayan salt lamp.
3. Hire a meditation coach. Pay them a lot of money. Let them lead you through visualizations of your happy place, which is a particular San Juan beach you enjoyed as a child. Remember that Puerto Rico has been ravaged by hurricanes. Oh my God, climate change.
4. Search YouTube for "self-guided meditations." Watch a thirty-second ad for fabric softener.
5. Get in bed. Put on an old episode of *This American Life*. Realize that Ira Glass is your spiritual leader as you drift off, lulled by a stranger's story about how he met his dog at a bar in Vietnam while folding origami cranes in protest of the 2008 US financial crisis.

IMPORTANT LIFE RULE: CUTTETH NOT THINE HAIR WHILST PISS'D

Are you sad? Angry? Overwhelmed? Go hug someone. Or do one of the things on page 100 (Simple Ways to Make It Better). Do not, however, under any circumstances, book an appointment at the salon, because what will happen is that it will be a mistake.

Draw the terrible haircut that you are not going to get.

ALSO MAYBE SKIP THE NEW TATTOO

Something got you down? You should totally get a new tattoo! Later. When you're not full of rage, misery, and/or various other judgment-clouding emotions.

Draw the tattoo you want to get someday but are not going to get right now.

← draw your future tramp stamp

ONLY AMATEURS FALL ASLEEP IN BEDS

As every anxious person knows, insomnia is more or less a full-time job: You start planning for the coming night's sleep the moment your eyes open in the morning, and structure your afternoon and evening to ensure maximum restfulness. No coffee after 3 p.m.! Yoga! Mindfulness! The writing-down of brain-cluttering minutiae in a minimalist notebook your roommate bought you because she couldn't listen to you wandering around in the middle of the night like a drunk zombie anymore!

At last, it is bedtime. And do you sleep?

Oh hell no. "Bedtime" for insomniacs can more accurately be described as "time to freak the fuck out." There is no sleeping in one's bed—but fortunately, there are plenty of other inappropriate places where you may find yourself passing out the next day.

PLACES WHERE YOU ACTUALLY FALL ASLEEP

During very important meetings

On public transportation, two minutes before your stop (ideally next to a Steve Buscemi lookalike)

Right before the movie gets really good.

In a wooden chair at your niece's piano recital

Journal:

Where did you most recently display those latent narcoleptic tendencies?

How'd that work out for you?

CIRCLE ALL THE WEIRD THINGS YOU'VE TRIED TO STOP SWEATING SO MUCH

Sweating! It's a natural part of being a ~~monster~~ human being. Everybody sweats, just not as much as you.

all-natural deodorant

shaving

lemon juice in places

trying not to move

sweat-wicking technology

garment shields

REVEAL THE SECRETS OF YOUR UNCONSCIOUS MIND!

Draw the thing. Yes, that thing. Draw it.

HOW TO:
CALM DOWN WHEN YOU'RE FREAKING OUT

Have you ever been in an inarguably stressful situation (say, you just erased the entire PowerPoint for the presentation that is happening in fifteen minutes, and now your computer is broken because okay, maybe you smashed it) and then had an altogether natural reaction (hyperventilation), upon which some random person instructed you to "just breathe"? This is unhelpful advice.

WHAT TO DO INSTEAD:

Breathe

But not because someone told you to; nobody who tells another person to "just breathe" should receive any kind of positive reinforcement. Do it because it is the scientific way to trick your body into thinking that things are A+, even if what's happening is that you're being chased by a polar bear. This is because deep breathing increases the flow of oxygen to your brain and stimulates the parasympathetic nervous system. Science!

Run cold water over your wrists

Your wrists have major arteries, so cooling them will help cool the rest of you, too. In other words, you'll literally chill out! (Sorry.)

Eat something crunchy

Chewing relieves tension in the jaw and lets you pretend that you're smashing the bones of all your foes between your teeth. Carrots are ideal, but if you did in fact break your computer, go get those Lay's.

Count backward from 100

This is harder than it should be and forces your brain to concentrate on something other than what's making you panic.

Eat chocolate

It regulates your cortisol (aka stress hormone) levels. Also it's delicious.

Check your jaw

Is it clamped down like you're a rottweiler with a ham hock? Stop it.

this is a ham hock, not a droopy panda

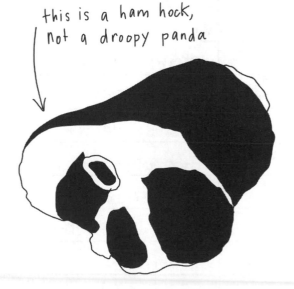

Smell some coffee

Smell some coffee. It can help reduce the aforementioned stress hormones . . . and also, you get to have coffee! (Not too much, though, or you'll get the jitters.)

WHAT REALLY MATTERS

○ Kids.

♡ Parents.

Grandparents.

Free food.

Kittens.

Finding a person you really like. (Not all the time, but most of it.)

♡ Naps.

Realizing there are things in your life that aren't how you wish they were, and then fixing them, like a badass.

○ If ~~people~~ you think you're super cool.

☆☆ Practicing.

☆ Resilience.

Whether the strawberry ice cream you just ordered has real strawberry pieces in it, because if not that is such bullshit.

♡ Water pressure.

Sticking up for people who can't stick up for themselves.

This place:

This person:

This random thing only I understand:

○ Magic.

WHAT YOU LOOK LIKE WHEN YOU MEET SOMEONE NEW VS. WHAT YOU THINK YOU LOOK LIKE

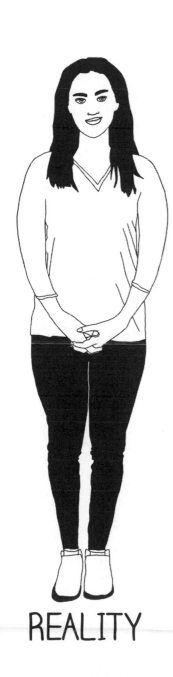

REALITY

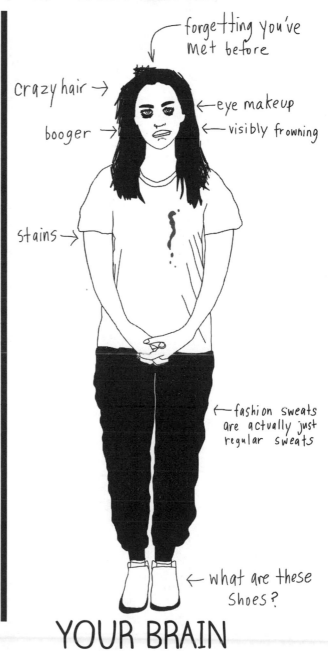

YOUR BRAIN

CUPCAKES ARE DELICIOUS

Here, have one.

DO SOMETHING NICE

Know what helps us every single time we feel like crap? Dropping the loop playing over and over in our heads about how awful/boring/stupid/whatever we are, and doing something nice for somebody else.

Here are some ideas:

- Tell someone at work they're doing a great job. Mean it.
- Do the chore your kid/partner/roommate was supposed to do so they can do something else.
- Pay for the person in line behind you at Starbucks.
- Give a stranger a sincere compliment.
- Take out your neighbor's trash.
- Let someone go ahead of you in line at the grocery store.
- Hold the elevator even though you're running late.
- Go through your stuff and donate what you don't use or need.
- Give a bigger tip than you have to, if you can afford it.
- Email a friend who's sad and tell them why you love them.
- Call your mother. Listen to her. Don't try to get off the phone.
- Apologize to someone you hurt in the past. Mean it.
- Ask the cashier/taxi driver/hairdresser questions about his or her own life. Listen to their answers, no matter how long they are.
- Offer to take a photo of a couple or family. Take a few so they can choose their favorite.
- Hide a few dollar bills in random places so strangers will find them.
- Give a friend a copy of your favorite book.
- Offer to return an elderly person's grocery cart to the rack for them.
- Notice the name on a store clerk's name tag. Use it.
- Dance to the radio in your car like a weirdo, and when someone notices you, smile at them and just keep dancing. It'll make them laugh, promise.

HOW TO:

DEAL WHEN YOU SAY GOODBYE TO SOMEONE AND THEN DISCOVER THAT YOU'RE WALKING IN THE SAME DIRECTION

There are few things more satisfying than a neat, tidy conclusion to a conversation.

 See you later!

 Bye!

AMAZING. You're done! Now you can go back to deciding whether it's acceptable for an adult to add Go-Gurt to an Instacart order, or checking your phone to see what fresh hell our country's leaders have gotten up to.
But . . . wait.
Oh, God.
Oh no.
You're both walking in the same direction. And now you must either have a meaningless conversation of indeterminate length with a person who does not want to be talking to you any more than you want to be talking to them ("Soooo . . . looks like we're headed in the same direction! Hahahahahaha"). Or you can do one of these things.

WHAT TO DO INSTEAD:

1. Walk extremely slowly. Or quickly.

2. Run!

3. Freeze! Humans only respond to moving objects and flashing screens, so if you don't move, make beep-boop sounds, or emit news alert pings, they will forget you're there.

4. Walk centimeters behind the other person, directly in their footsteps. Let them feel your breath on the nape of their neck. If the desire to moan strikes, don't resist it. This person will never walk anywhere near you ever again.

5. Start humming "All By Myself" and hope they get the point.

6. Scream in agony, collapse to the ground, then performatively dump the "shard of glass" out of your shoe. Bleed a little, if that's something you can do on command.

7. Get a pretend phone call.

8. Have a pretend phone conversation.

9. Be put on pretend hold.

10. Actually call someone.

11. Pretend to walk in the other direction, then circle the block so you're in front of the other person, jump out from behind a bush, and yell, "SURPRISE, MOTHERFUCKER!"

12. Just sit down right there on the ground and don't move.

MATCH THE OBSCURE DREAM SYMBOL TO ITS (ALLEGED) MEANING*

Discover what last night's dream about quadruplets with dandruff eating nachos (might) mean.

draw your dreamscape ⤶

THING

1. Aardvark
2. Dandruff
3. Demon baby
4. Dentures
5. Cannibalism
6. Earplugs
7. Eel
8. Fanny pack
9. Holding public office
10. Tissues
11. Long earlobes
12. Madonna
13. Mayonnaise
14. Nachos
15. Nasturtiums
16. Nesting doll
17. Paper bag
18. Parking ticket
19. Quadruplets
20. Record player
21. Scallop shell
22. Smelling your armpits
23. Tan lines
24. Washing hands
25. Yams
26. Yeti
27. Yodeling

THING'S ALLEGED MEANING

A. Sex
B. Looking for acceptance
C. Pros and cons
D. Anxiety about a new project
E. Sensuality
F. The truth behind all the layers
G. Forbidden desires
H. The search for balance between rationality and emotion
I. Desire for a time-out
J. Patriotism
K. Deceitfulness
L. Disappointment
M. Guilt
N. Secrecy and cautiousness with regards to business dealings
O. Going in circles
P. The womb
Q. Social status
R. Low self-esteem
S. Feminine power or materialism
T. A need to let go of the past and move on
U. Connection between mind and heart
V. Acceptance of consequences
W. Isolation
X. Commitment issues
Y. Feeling out of place or not fitting in
Z. Being judged
AA. A period of chaos and problems

According to DreamMoods.com, which uses highly scientific assessment tactics to arrive at conclusions like "To play a xylophone in your dream indicates concerns for the environment."

THE REVENGE PAGE

Remember how, in grade school, you used to draw illicit things in your class notebooks (boobs with enormous areolas, the word SHITFUCKER, your teacher naked, etc.) and then frantically draw over them until they were hidden under a billion scribbles? No? Just us? Well, you missed out. Give it a shot.

1. Write down the name of someone who was really, really mean to you in elementary school. Write "IS A JERKFACE."* Decorate it. Go crazy. If you feel the need to draw a picture of them with pimples and a bad haircut, definitely do that.
2. Now draw circles around and over your creation until it is obscured, so that no one who walks by and casually glances down at this page will see anything more than a big black smear.
3. Feel superior with all your secret knowledge that _____ is, in fact, a jerkface, and now it's official.

*Feel free to improvise here.

WORD LADDER: CURSE WORDS

Make as many different words as you can out of each curse, changing only one of the letters each time. All words have to be real (and we will enforce this Very Important Rule via the microchip embedded in this book's spine, just in case you were planning on suggesting that THIT is a word. It is not).

FUCK	SHIT	CRAP	SIRI
DUCK	_____	_____	_____
LUCK	_____	_____	_____
LACK	_____	_____	_____
_____	_____	_____	_____
_____	_____	_____	_____
_____	_____	_____	_____
_____	_____	_____	_____
_____	_____	_____	_____
_____	_____	_____	_____
_____	_____	_____	_____
_____	_____	_____	_____

IF YOU CAN GET THROUGH THIS MAZE, YOU WIN EVERYTHING

TRYING TO COMPLETE THIS MAZE IS LIKE WATCHING THE MOVIE *INCEPTION* ON REPEAT: AN EXHAUSTING EXERCISE IN FUTILITY THAT'S GUARANTEED TO END WITH A HEADACHE.*

START

END

*Spoiler: This maze goes nowhere. It, like trying to entertain a bus full of people by singing "Copacabana (At the Copa)," is a game you cannot win.

COLOR IN THIS CALMING GRANDMA

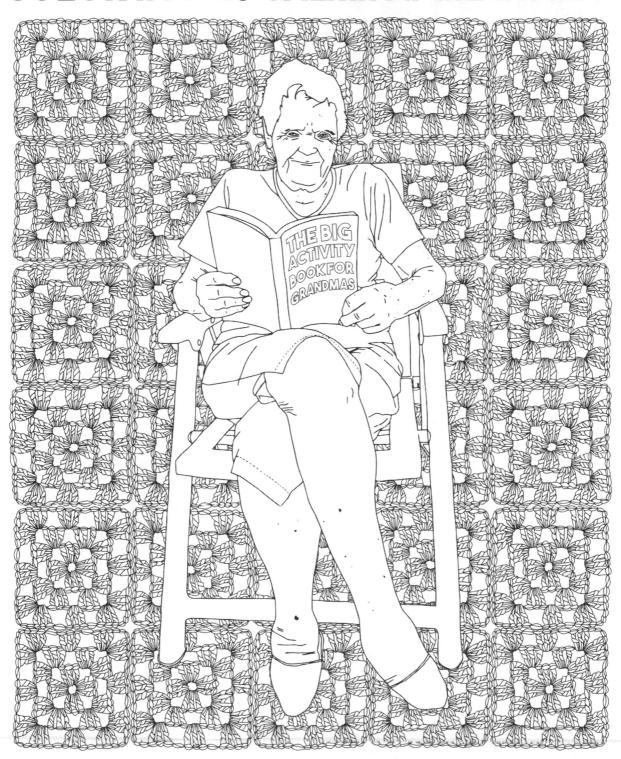

HOW TO:
HANDLE RIDING IN AN ELEVATOR WITH SOMEONE

Being trapped in a metal box with another person (especially if you've met them before but cannot remember whether it was at summer camp that time you got scabies or over chilled pâté at your firm's Christmas luncheon) is one of life's great treasures—a bounty of potential awkwardness.

TO MAKE IT THROUGH ALIVE:

Read words. "Floor." "3." "Alarm." Take your time.

Jingle things.

Spend a moment in genuine contemplation of the physics of the machine you have put in control of your life.

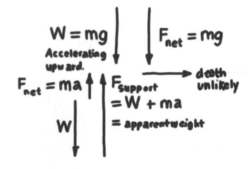

$$W = mg$$
Accelerating upward.

$$F_{net} = mg$$

$$F_{net} = ma$$

$$F_{support} = W + ma$$

death unlikely

$$= apparent weight$$

$$W$$

Try to remember any Robert Frost line other than "I took the one less traveled by . . ." Or was it "taken by . . ."? Hm.

My best guess: _____

Hey, that's pretty cool wallpaper for an elevator.

draw it here ⟶

Stand facing the side of the elevator.

Alt: Stand facing the other side of the elevator.

Check your cell phone, holding it at a 45-degree angle so no one but you can see that it's dead.

Remember that scene in *Speed* when the elevator cable snaps and Keanu Reeves has to rescue everyone from certain death? Pretend you're in the part right before that, when everyone's just standing there.

DRAW WHAT YOUR CUTICLES LOOK LIKE

THINGS TO DO INSTEAD OF DESTROYING YOUR CUTICLES

Chewing on and picking at your cuticles is Anxiety 101. Clearly you already do this and know you need to stop. If you're looking for some next-level compulsive behaviors to mix it up, here are some things you might want to try instead. Check all that you'll try.*

- ☐ Remove the pills from your sweater, one at a time.
- ☐ Remove all traces of earwax with a Q-tip cotton swab. Are you positive you didn't miss any? Double-check.
- ☐ Pluck any and all stray hairs on your body.
- ☐ Find any and all pimples, no matter how tiny and insignificant, and pop them.
- ☐ Ignore the fact that you look worse now. Locate your significant other. Do this to them, too.
- ☐ Google YouTube videos of people doing all of the above.
- ☐ Make videos of yourself doing all of the above, and put them on YouTube.
- ☐ Use a toothpick to comb your hair for errant dandruff.
- ☐ Do that thing where you stab a knife in between each of your fingers as quickly as you can.
- ☐ Watch Fox News.
- ☐ Call the AT&T help hotline and try to have a productive conversation that comes to a satisfactory and mutually agreeable end.
- ☐ Chew on your toenails (while also improving your flexibility!). Don't let people see you doing this, because it's super gross.
- ☐ Make a list of all the lists you need to make.
- ☐ Go to Ikea with someone you love.

**All these things do in fact help you not bite your cuticles. None of them is a good idea.*

SIX THINGS LOWER

A small child's ability to hold pee

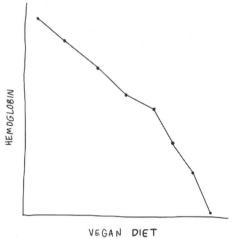

A vegan's hemoglobin level

Your monthly Netflix bill, since you still have your ex's password

THAN YOUR CREDIT SCORE

Any man's threshold for the common cold

Loafer socks

The amount of money any dealership will give you for your car

Also: the number of minutes you want to chat with the guy playing Henry VIII at the Renaissance faire, the number of STDs you've contracted, your average bowling score, the number of calories in tea, and the population of Gilbert, Arkansas.

THE APOCALYPSE IS NIGH

HOW TO:
DIY AN UNDERGROUND BUNKER

If life has occasionally left you wishing that you could dig a big hole in the ground, crawl inside, and spend a few years hanging out in a world free of human interactions and CNN news alerts, good news! You can buy a bunker. You can even order it online!

The bad news: An "economy" bunker will run you about $45K ($45K that you could also spend on 11,260 bottles of Tums Ultra tropical fruit flavor—an equally solid investment). But if you're determined to build a spot in which to sequester yourself in the event of natural disaster and/or your in-laws' next visit, you can always DIY one.

It's pretty straightforward.

WHAT YOU NEED:
1. Various government-issued permits
2. An excavator
3. Knowledge of the area's pockets of natural gas, radiation, and mold
4. An air filtration system
5. A composting toilet
6. Concrete-filled steel envelope blast doors with rotating cam latches and high-level ballistic resistance
7. A blast hatch with a 360-degree rain lip sized to match the backfill depth of your underground square footage
8. A preset overpressure valve, a differential pressure gauge, and a register duct kit
9. A backup hand pump for when everything else stops working
10. Someone with an engineering degree
11. Someone who knows storage protocols

12. Someone who knows maintenance procedures
13. Someone who knows how to make concrete roofs not collapse
14. Someone who knows how to support human life in a hazardous, unforgiving environment where things like breathing, seeing, and existing, generally, should not be possible

ALT:

Buy one of those pop-up tents they sell at Target, get inside with your blankie and an iPod, and listen to "We Are the World" on repeat.

RARE ESSENTIAL OILS FOR ANXIETY

Essential oils are lovely, like a massage for your nasal cavity. Just place a few drops of lavender in your diffuser at night and wait for the magic to happen: Your jaw will unlock, your AT&T bill and the weird bump on your dog will be erased from your mind, and you'll experience the ethereal calm of running through a field of flowers as the sun lifts over the horizon on a spring morning. If lavender doesn't work, try the below.

TRAPPED IN AN UBER WITH NO CELL SERVICE

WORST. At least you have your activity book handy! Soothe your sad, dull brain that has been deprived of blinky stimuli for ten entire minutes.

1. Wonder whether your precise latitude and longitude were just transmitted to a Russian data harvester via satellite. Wonder whether anyone in Russia would even care where you are. Wonder whether anyone cares where you are. Wonder whether you remembered to turn off the coffee maker.
2. Match up your personal qualities against what you remember about natural selection. Decide whether your genetic material is likely to be included in future generations.
3. Put your phone against your ear and occasionally say, "Really?" so your driver knows you know people.
4. Locate the name and ID number of the driver "just in case." Write it on your arm in Sharpie marker so the police will know who to pay a visit to when they find your body.
5. Wonder whether this actually is a shortcut, or if the driver is taking you to a secret warehouse containing a bathtub full of Gatorade.
6. Refresh your Facebook feed so you'll know the moment your service comes back. Refresh it again. And again. Make sure not to miss anything.

SOOTHING FACTS
ABOUT
HAND SANITIZER

Hand sanitizer: the miraculous elixir that has allowed millions of human beings to touch subway poles without dying. If you're single-handedly keeping the Purell family on the Forbes 100, here are some facts about hand sanitizer that'll make you feel better about that (extremely legit) life choice.

- It kills *Mycobacterium tuberculosis*, aka the bacteria that causes TB. Granted, Frédéric Chopin, John Keats, and Edgar Allan Poe all had TB, so if you contracted it, too, you'd have a toe in the door of the canon of Tortured Genius White Men Who Got Sneezed on by Someone. But really, when you can say goodbye to Source of Stress #15,035—Expiring from Consumption—why not go ahead and do that?

- It's recommended by the CDC for use in health-care settings, and the CDC is way disinterested in seeing horrifying diseases get around.

- The use of hand sanitizer with at least 60% alcohol does not contribute to the creation of superbugs (it kills the germs before they can evolve to develop resistance). This is great, since superbug creation is the opposite of the point.

- It's one of the only things everyone agrees you should put on babies, so that must mean something.

- The ethyl alcohol in hand sanitizer works by destroying the cell membranes and denaturing the proteins of bacterial cells. Translation: It's really good at killing bacteria with thin cell walls. Guess what bacteria has a thin cell wall? *E. COLI.* Bam.

- "All-natural" versions are generally less potent and thus less helpful, so you don't have to feel guilty for just buying the Walmart brand instead of making it yourself with organic amaranth oils and essence of hogwart.

COLOR IN THIS GODDESS

SIMPLE WAYS TO MAKE IT BETTER

Not all these things will work. But some of them just might. Circle your favorite ideas.

Burn a fancy candle

Listen to Huey Lewis and the News

Knit something

Zone out for a minute

Clean the house

Get the fancy coffee

Make s'mores

Do a puzzle

Take the dog for a walk

Delete your ex from your phone

Put up Christmas lights

Eat movie theater popcorn

Pet your cat

Go to the library

Take a shower

Eat Cheetos

Look through childhood photos

Bake

Stretch for 15 minutes

Drink tea in bed

Write about it

Lie down in the grass

Read an actual book

Put on sweatpants straight from the dryer

Get in the car and just drive

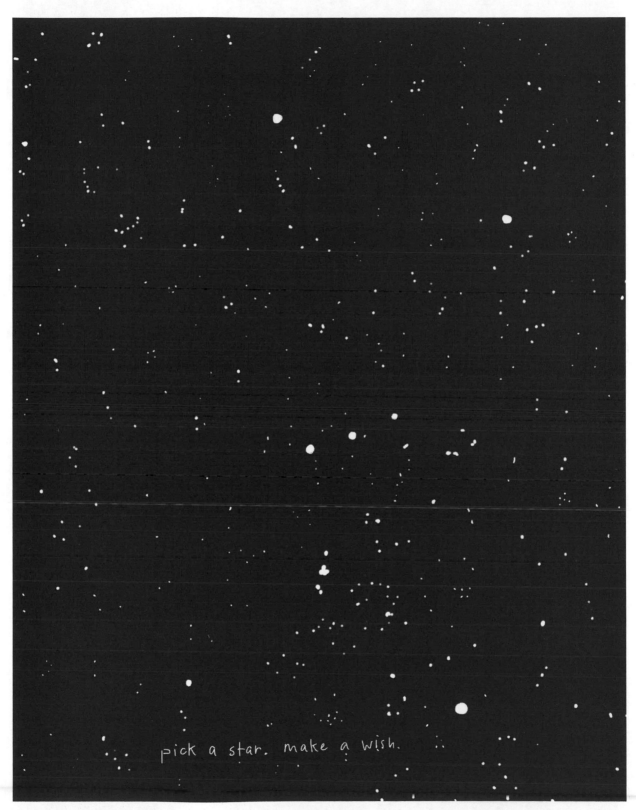

pick a star. make a wish.

REASONS TO BE GLAD YOU'RE NOT LIVING IN THE 18TH CENTURY

In the eighteenth century, you could both drink from and poop in the Thames. So efficient! More reasons why you can congratulate yourself on not having been born a few hundred years ago:

RAW SEWAGE NEXT
 TO YOU
NOT BIG ON BATHING
OR BRUSHING
 TEETH
ARCANE SURGICAL
 INSTRUMENTS
ARCANE SURGICAL
 PROCEDURES
SURGEONS
 ACTUALLY JUST
 BARBERS
WET HORSE SMELL
POOP IN WATER
SO MUCH LICE
BELIEVE EATING
 MERCURY CURES
 LICE
CHAMBER POTS

CHOLERA
SMALLPOX
TYPHUS
WIGS

NO TOILET PAPER
NO DEODORANT
NO TAMPONS
NO DIET COKE

NO MEMORY FOAM MATTRESSES
NO NETFLIX
NO CHILL

```
S T O P R E B M A H C L L I H C O N N O T B I G O N B A T H I N G B F K P K C D
S E R U D E C O R P L A C I G R U S E N A C R A N O T N A R O D O E D O N P P Q
X V K C E B S B S Y M O X M A F B U N R N B D L R N X Q J I L Z M L J L W U Y T
S I X I Q K Z R J K C M X X D O O T W O I F H K A E X W G R K L R I M S D C U P
O Z H N U O I D E F V M P Y R Y Y J K R P K Z Q H T I V F H Y A N E R O F H T W
M L F U L Z W J O B Y R Y A O I C E H Q P M Z Y K F H I G G G B R V U D Y X F W
U T C B U M N J N F R N B T N T P P W Z T I A R W L C B I Q R B V E Y J I X N K
C Y A L Z U O L M U T A T I Z T G B K V I T J T G I A B F J E Y I E C X P V Y S
H R A S R L H X J H T X B A B X W J R S V H K V O X R M W D T X U A Z W F T Z W
L R H W W R M K C X E M K T V E L Y U G T D C T L N C Q L Y O Y T T F W D B U C
I H Q U C P B M Q N K G Y J S G Z Q V E O N P B H W A P B U O F V I Q W Q X X M
C Q Y Y Y I Z M E H L P S E K U Y V Y T S B G Z U G N S T R V X B N V S S X O K
E F W S O G Y G Z R B Y H H J J J U X R C F Q X M K E L C G O M B G E M Y Z B J
D K Q S M L A N U N P I G V C J O Y U W O M D T L Q S V E L P Q S M W E E C A M
M T S E B W D E V O C V S U T J S X L Q O X T E J K U B M G G K L E P G S N C Z
T K C R E C O F V Z D W Q K W O A N G L A O T J X V R H W G K Z V R O U D L Z S
Q B Y S Z R V B T T K X L P E L G K L J A O M I X J G T A O D M B C X R F C C B
F H W E H G W S J I O L P M R D P C Z V C U B N B K I G A E R L A U P W Z S C S
N A O Z B Y S D Y L E Y M L X S H P V E E C T G W E C O N I H K A R G C D O A A
R N A U N L X O Z M C Y A H A Q V R O R M L X C K M A A O H O W W Y Y C M U G N
T S C L T S Y Z S P O O P I N W A T E R Z O Z O A Z L Z T Z Z Z Z C Z Z Z Z Z Z
O X O M H Y J E E Z L L K W Q P E V H O P J C R S S I O O U A D M U S F L U F W
Z R Z H N O S H S I F P W G U V W O Z L S T C B H L N T I E N N L R P S B A T K
Y C B U R R U K Z I N F U B P M N M L B E A S H J X S O L E Q H W E O K M F B D
I A T R O N P H W T V O N T F H Q A G I F J A C A G T A E O K E V S S R K X E T
G P R H U C C M W X R B J T H T M U D S D U M U T T R T T G P O Q L G A O R A F
M Q T E N S M J T I Z Q P L Y S A O I G I K H S D H U I P P R N M I L P G T T C
W E N O L I H V R L G H Q I B W N O F D W A R H N W M V A W A U F C T T V D D X
W O E X L O Y I Z A L S O H P C J E X U Q S G D E R E L P N F B S E Z K Q L N Q
D V U S U Q H P N B I C G I R C M B T A R Q Q U I G N H E N H C F I X U V R B I
V K D N G N B C O G Y B N O M E M O R Y F O A M M A T T R E S S E S L F S E D C
J H B C Z Z Z X C V J T T J J S C F P O Y I N S J M T S G V F J O Y F N C T Y Y G
Q X M B J H L U U A I E L O Z W Q Q H R B R G J Y O B A B Q G L L M V Q H X H M
I J A N E R M Y Q R V W E P M G X J O T D L L V T M V E C B B H V K Z Z A N X Z
P M I Z V F N I N R F Q Y T T C Q P Z O K H I I K D L O U E O K U T V Z K R W L
G O F Z M D T N E T D Y Q M H J B A R V M Q O P X C B L O X E M L L M A C Y F D
T Y P H U S M L A P P N V H S Q W G T S R X T Z P K W Y S Z W N K Z U B N F L E
W V T L N C M W S L D G H X A R S J Y C P Y P E D I N Q F N S R R K A K M M R H
V T U F R Z G H J Z R V B Z Y B S D J B W E L B C R R I B P K R I D V I I Q D P
C I M B Z K G T T C F Y R E U V H G M Z C Z U G U X I U J E C Z K Q J J K L V B
```

Journal: Also, those: _____

CIRCLE THE COMPONENTS OF YOUR IDEAL WEEKEND

unattractive
sweatsuit

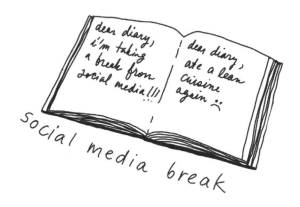

social media break

home security system

a lot of toilet paper

bath bombs

every charger in existence

delivery

Netflix (chill optional)

TOP FIVE

CALMING THINGS

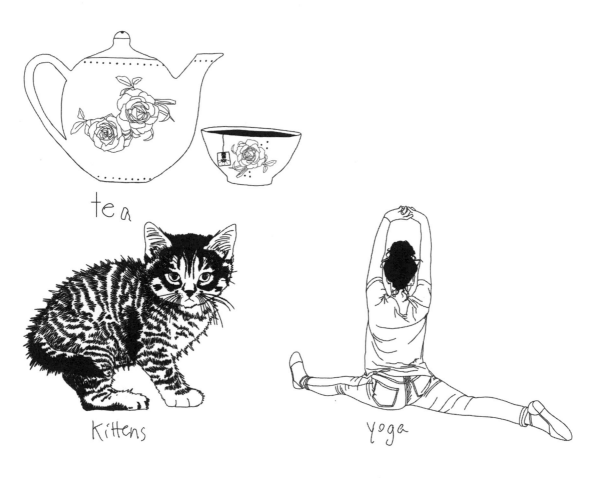

tea

kittens

yoga

1. _____

2. _____

3. _____

4. _____

5. _____

BLIND MAZE: AVOID THAT EYE CONTACT

Everywhere you go, there are people. So many of them. They are looking at you. They want you to look back at them. And if your eyes do meet—even accidentally—they may even want to talk to you. This is obviously intolerable.

Take a good, long look at the drawing below. Then grab a pencil, close your eyes, and see if you can get from your office all the way to your bed without running into any needy fellow humans.

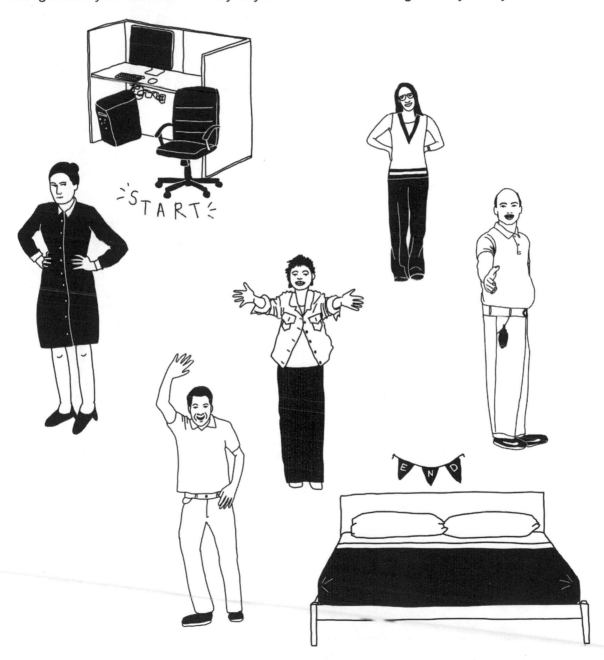

YAY, THESE THINGS EXIST

Shake Weights

lip balm

blackout curtains

bathroom
door
locks

homing devices

The
Rock

Journal:

Here are some things that make my heart grow like the Grinch's:

THE END IS NIGH!

Hand this page over to a partner, who will prompt you for each blank, then read your epic creation out loud.

I woke up this morning, and the first thing I noticed was that my _____
 pet

was _____. Weird. Then I realized all the _____ in my
 verb ending in -ing plural noun

room were _____. I heard a huge _____ and started
 verb ending in -ing sound

to _____. All of a sudden _____ ran by, screaming,
 verb person

"_____!"
 expletive

"What's going on?!" I asked.

"A _____ _____ _____ out of the
 adjective noun verb, past tense

_____! It started eating all the _____, then smashed the
 body of water plural noun

_____ with his _____ _____!"
 famous building adjective body part

Just then, I heard a _____, and a _____
 sound vehicle

_____ up. Sitting in the driver's seat was none other than
 verb, past tense

_____! "_____!" he/she said, and so obviously I got in. He/she
 celebrity order

handed me a _____, which immediately started to _____.
 noun verb

We picked up a few more _____, and then it was time to get the hell out.
 plural noun

"We've established a colony on _____!" said _____.
 planet same celebrity

_____ and _____ are already there, and they've set up a
 celebrity family member

_____ made out of _____. I think we'll call our new home
 structure plural noun

_____. (Actually, it sounded kind of nice).
 noun

TOP FIVE

PLANS TO SURVIVE A NATURAL DISASTER

Locate the guy who plays Daryl in The Walking Dead. Befriend him.

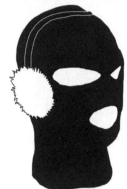

Find a balaclava and a pair of earmuffs. Put them on. Ignore everything.

Enjoy the analog life for a minute.

Find a biodome. Go in it. Stay there.

1. _____

2. _____

3. _____

4. _____

5. _____

COLOR IN THE PANIC-INDUCING BATHROOM!

PUBES! A CLUMP OF WET HAIR! HEAD LICE CREAM! AN EMPTY ROLL OF TOILET PAPER!

YOUR HOTEL ROOM CARPET: A PETRI DISH OF HORRORS

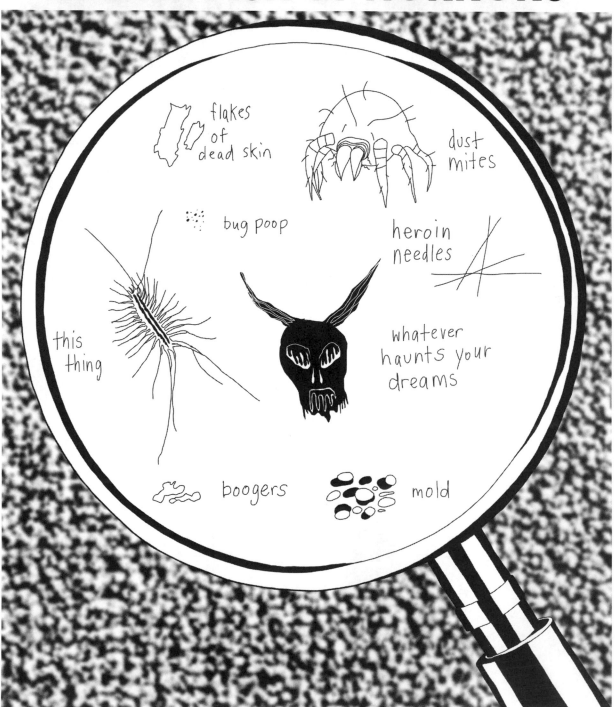

WORD SCRAMBLE:
THE GERMIEST SPOTS IN YOUR HOTEL ROOM

There's just no getting around it: Hotel rooms are gross. Learn from our mistakes and do not search online for "Are hotel rooms clean?" It will only make you feel much, much worse.

*On your next stay, do your best to avoid these germ hotbeds—and remember to bring wipes.**

GLITCH WHIST _____

HELOT PEEN _____

SPOKESPERSON EUGE EH _____

EFFECT OOP _____

KNAGGINESS DIRLS _____

LIB BE _____

EMOTER _____

BARED PEDS _____

*If this page gives you palpitations, flip over to page 98 for some soothing facts about hand sanitizer, and remember: The world is a disgusting place no matter where you are, and most people make it through a night at the Westin without contracting C. diff. Definitely bring wipes, though.

Answers: Light switch, Telephone, Housekeeper's sponge, Coffeepot, Drinking glasses, Bible, Remote, Bedspread

THE DENTIST'S OFFICE

Is there some reason why dentists don't install televisions on their ceilings so their patients can float away on a cloud of Real Housewives *instead of experiencing every movement of the ice pick hacking away at their gums? It seems they'd prefer you just lie there, alone with your thoughts, listening to the hiss of the barely functional saliva-removal device in your cheek while the back of your throat slowly fills with bloody water.*

COLOR IN THIS WONDERLAND OF TERROR!

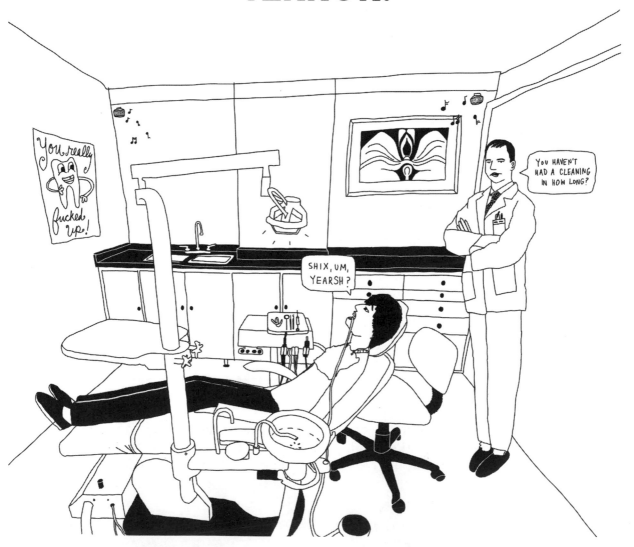

HORRIBLE DENTAL THINGS

Match the torture devices pictured below—which may make you panic, cry, or panic-cry—with their name.

1. Dental torque wrench ——————
2. Tongue retractor ——————
3. Dental explorer (aka sickle probe) ——————
4. Dental syringe ——————
5. Cheek retractor ——————

A

B

C

D

E

Answers: 1.D, 2.E, 3.A, 4.C, 5.D

115

THINGS I'M NOT AFRAID OF

Just so you know: You're pretty badass. Take a moment to recognize all the things that don't give you anxiety. Or that used to, but you overcame that shit (badass).

I used to be afraid of . . .

1. _____
2. _____
3. _____
4. _____
5. _____

I'm definitely not afraid of . . .

1. _____
2. _____
3. _____
4. _____
5. _____

DRAW YOUR FUTURE

COLOR IN THESE FREAK DEATHS

Heraclitus, a Greek philosopher, was eaten by wild dogs after smearing himself in cow shit.

Edmund Ironside was stabbed to death by an assassin while on the toilet.

Adolf Frederick, King of Sweden, died after a meal of lobster, caviar, smoked fish, champagne, and 14 desserts.

William Snyder, 13, died when a clown swung him around by the ankles.

THINGS YOU CAN STILL EAT WHEN THE GLOBAL FOOD SUPPLY DWINDLES

We're inundated with paralysis-inducing choices: McDonald's or Burger King? Salsa or guacamole? Gluten-free hemp toast with avocado and a soft egg sprinkled with microgreens and Hungarian sweet paprika, or food that takes less than a paragraph to describe?

The good/bad news is that we're thisclose to a dwindling global food supply! Soon all our homogenized monocultures will be eradicated by fungal plights and whatever is happening to all the bees, and we'll all just be shoeless in the grass, munching crickets and wondering where we went wrong.

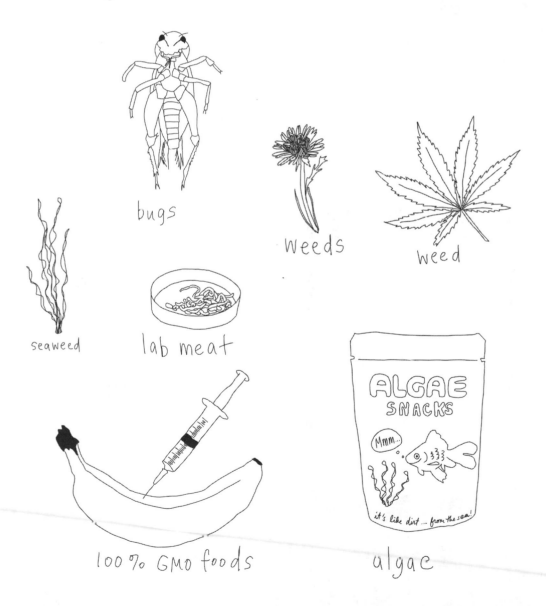

bugs

weeds

weed

seaweed

lab meat

100% GMO foods

algae

THINGS ANXIOUS PEOPLE SHOULD AVOID

those scary metal trapdoors on sidewalks

snorkeling

people who are both younger and more successful than you

googling "skin rash"

12 cups of coffee

MATCH THE MOMENT THAT WILL FOREVER HAUNT YOUR DREAMS TO THE CORRECT MOVIE

There's nothing like an alien-bursting-out-of-someone's-body scene to make you realize that hey, things could be worse.

Very hairy girl leaves TV.
There's a clown in the sewer.
Gwyneth Paltrow's head in a box.
Pea soup projectile vomit.
So much elevator blood.
Chest-bursting scene.
Veiled girl in a confirmation gown.
Zelda scuttling toward the camera.
Mike faces the wall.
Jamie Lee Curtis in the closet.
Pig blood shower.
Stalking via night vision goggles.
Geena Davis gives birth to bug.
Katie gets dragged down the hall.
Drew Barrymore on a landline.
Learning what "hobbling" means.

Carrie
The Exorcist
Paranormal Activity
Scream
The Fly
It
Pet Sematary
The Others
The Silence of the Lambs
Se7en
The Shining
Most horror films
The Blair Witch Project
Alien
Misery
The Ring

Draw your own!

...AND NOW WASH YOUR BRAIN WITH THESE ADORABLE PUPPIES

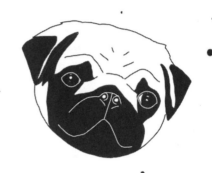

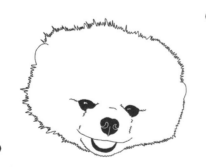

draw your own pup here

THESE ARE A FEW OF MY FAVORITE THINGS

*Life got you down? Sometimes just remembering the things that make us feel good can be calming. If this doesn't work, try drugs.**

List your favorite things below.

Flower: _____

Candy: _____

City: _____

Appetizer: _____

Animal: _____

Person: _____

Movie: _____

Book: _____

Type of alcohol: _____

Friend: _____

Sport: _____

Illegal substance: _____

Poet: _____

Smell: _____

Tropical island: _____

Dessert: _____

Activity book: _____

*Kidding! Unless they are prescribed to you by a medical professional, in which case go right ahead.

YOUR WORST FEAR, CONFIRMED BY ASTROLOGY!

Aquarius

Personality: Soothing and mellow, or loud and obnoxious (just to keep people on their toes). You have great ideas but are crappy at things like emotions.

Phobia of Choice: Animotophobia, the fear of feeling stuff. If you are in a relationship with an Aquarian, you should probably take the money and run. If you are an Aquarian, please change.

Pisces

Personality: Understanding and intuitive, as evidenced by the fact that your symbol is the fish, and fish are known for their emotional intelligence.

Phobia of Choice: Ornithophobia, the fear of birds. Because you don't want to be eaten by them.

Aries

Personality: Stubborn, passionate, assertive, honest, and impatient. In other words, exactly like a ram.

Phobia of Choice: Macrophobia, the fear of long waits. You should never go to the DMV without a fully charged phone and a fistful of Vicodin.

Taurus

Personality: Unafraid of hard work, so long as you get to define the term "hard work."

Phobia of Choice: Ergophobia, the fear of employment. If all you want to do is open an Etsy store that sells custom watercolor poodle portraits, anyone who tries to stop you will wish they hadn't.

Gemini

Personality: Emotionally intelligent and excellent at gathering information, aka a gossipy partier.

Phobia of Choice: Whatever the opposite of catoptrophobia (the fear of mirrors) is. You think you are spectacular, and everyone else does, too.

Cancer

Personality: Creative, loyal, and crabby (hee).

Phobia of Choice: Telephonophobia, the fear of talking on the phone. Because if you're talking to someone on a phone instead of in person, you won't be able to stare into their eyes in a creepy effort to read their mind.

Leo

Personality: Basically like Leonardo DiCaprio, a Leo in a myriad of ways.

Phobia of Choice: Gerascophobia, the fear of aging. This is why Leos, like Leo, tend to choose partners who are too young to legally drink alcohol but do anyway.

Virgo

Personality: Perfectionist in the extreme.

Phobia of Choice: Atychiphobia, the fear of failure. You never do, though, so as fears go this is a solid choice.

Libra

Personality: Smart, sweet, and selfless.
Phobia of Choice: Autophobia, the fear of being alone. Bless your smart, sweet, selfless little heart.

Scorpio

Personality: Trailblazers who are honest to a fault, even when it might make someone cry.
Phobia of Choice: Aphenphosmphobia, the fear of intimacy. You like to bring someone close and then violently push them away without explanation, so as to inflict maximum damage on all involved. You are mean.

Sagittarius

Personality: Imaginative wanderers who don't like worrying too much about boring things like responsibility.
Phobia of Choice: Claustrophobia, the fear of confined spaces. This can be interpreted both literally (you hate being trapped) and metaphorically (you hate being trapped), making you a swell life-partner choice for someone who enjoys being abandoned.

Capricorn

Personality: Conventional and middle-manager-y. You love all things #basic.
Phobia of Choice: Rachelmaddowphobia, the fear of Rachel Maddow. All that liberal, out-of-the-box thinking: shudder.

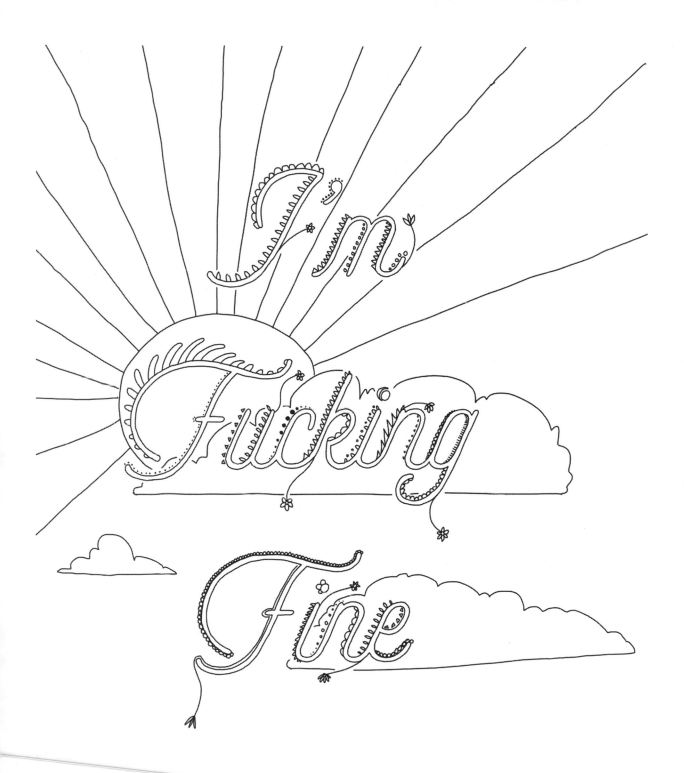

I'm Fucking Fine

YOUR PERSONAL CAN'T-HANDLE LIST

Everyone has them: Things They Cannot Handle. Bugs with wings. Hearing the word "moist." Oatmeal cookies with raisins (aka disappointment in baked-good form). Check the appropriate column for each thing below.

THING	CAN HANDLE	CANNOT HANDLE	SECRETLY ENJOY
Gas station bathrooms			
Making concrete plans			
Hotel room pillows			
Sweaty handshakes			
Armpit smells			
Comic-Con			
Calling your grandparents			
Drinking straight from the carton			
Garden gnomes			
Used clothing			
A baby crying			
"So what music are you into?"			
Personal space invaders			
Abercrombie & Fitch stores			
4:45 p.m. on a Friday			

THING	CAN HANDLE	CANNOT HANDLE	SECRETLY ENJOY
Someone typing really loudly			
Double dipping			
Twitter			
Unmade beds			
Hootie and the Blowfish			

Journal:

Mostly I need these things to not exist:

ACTIVITIES FOR INSOMNIACS

Any true insomniac knows the time-honored, go-to, middle-of-the-night activities: eat things, drink things, stare at clocks, take pills that will either make you fall asleep (good), or hallucinate (bad). It's nice to switch it up from time to time.

1. Make sheet angels (like snow angels, but with sheets).

MASCARA, EYE SLUDGE

2. Lie facedown and open and close your eyes a bunch of times. Check pillow for residual mascara and/or stray eye-gunk globules.

3. Consider masturbation, then remember it's exhausting.

← STILL GOT IT

4. Ask someone to fold you up in a comforter like a burrito. Pretend you're a newborn with no problems. Think about how delicious burritos are.

5. Are you sure you can still touch your nose with your tongue? Double-check. If you can't, there's no time like the present to start practicing!

6. Open your news app. Scrutinize trending articles to calculate the likelihood of the Eastern and/or Western Seaboard falling into the ocean due to an earthquake/tsunami/hurricane/act of a vengeful higher power. Close your news app. Repeat every few seconds as needed.

7. Toe yoga.

8. Divide your partner's snores into at least four different categories. Assign each one a celebrity alter ego.

EXAMPLES

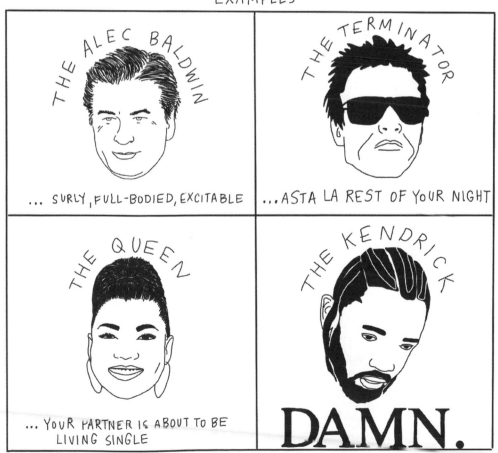

THE ALEC BALDWIN
... SURLY, FULL-BODIED, EXCITABLE

THE TERMINATOR
...ASTA LA REST OF YOUR NIGHT

THE QUEEN
... YOUR PARTNER IS ABOUT TO BE LIVING SINGLE

THE KENDRICK
DAMN.

YOUR DREAM TONIGHT

Hand this page over to a partner, who will prompt you for each blank, then read your epic creation out loud.

You're standing in the middle of _____, about to _____
 sports arena verb

the _____. All of a sudden, you look down and realize you're wearing
 noun

nothing but a/an _____. You hear someone say "_____!"
 article of clothing exclamation

and look up to see _____ staring at you. "I just got married to
 name of ex

_____!" he/she says.
 celebrity

 Suddenly, you're sitting at a desk in _____. _____
 name of your high school name of classmate

is next to you, and walking toward you is _____, wearing a/
 name of teacher

an _____ and holding out a piece of paper. "It's your final exam in
 noun

_____," he/she says. "I certainly hope you studied."
 plural noun

 You run out of the room and down the hallway, which is filled with _____
 color

_____. Ahead of you is a _____, and you jump inside but
 plural animal vehicle

can't seem to start it. You begin _____, and then the _____
 verb ending in -ing same vehicle

turns into a _____ that's going straight toward a(n) _____
 vehicle noun

that happens to be coated with _____. Just before you hit it, everything
 liquid

around you disappears and you find yourself falling down, down, down toward the ground

(which is, of course, covered with _____).
 plural noun

 Fortunately you can't die in dreams, so that's when you get to wake up.

 Good morning!

TURN THE WEIRD SQUIGGLE INTO A COMFORTING THING!

make this an
adorable animal

make this a
delicious food

make this a
getaway vehicle

make this a
self-care ritual

make this a
comforting mom

just let this
mess be a mess

"YOU LOOK NICE TODAY" AND OTHER SINCERE COMPLIMENTS

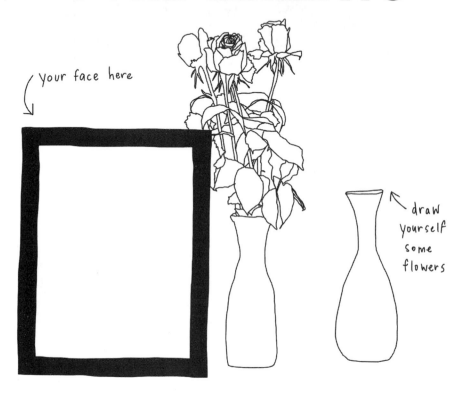

your face here

draw yourself some flowers

- Wow, you look great! Have you been eschewing modern/impossible beauty standards and choosing to instead accept how fucking amazing you are inside and out? It shows!

- I love your hair! It looks like you went out last night and had an awesome time, or stayed up late working on a fulfilling project. It's inspiring that you went out for coffee this morning without staring into the mirror for forty-five minutes. You look like someone with much cooler shit to do than hang out with a blow dryer.

- You look so well-rested! I'm proud of you for not staying up late working on that thing. We all need time off to rest and restore ourselves. Good for you for taking the time you need and not pushing yourself to the breaking point.

- Fantastic job not getting tanked last night and going home with that creep from the bar! You exercised great judgment there. You're amazing.

MATCH THE EVENT TO ITS LOGICAL CONCLUSION

You decide to throw a dinner party for your own birthday.

You pop into Target "just for a roll of toilet paper."

You eat kale salad on a date to be "cute."

You eat pepperoni pizza on a date to be "real."

You let your insurance lapse because you feel super healthy these days.

You go to Whole Foods "just for a loaf of bread."

You take a horrifying and noisy shit at the office.

You go to a "swinging party" assuming it involves . . . you know . . . swings?

You find a lost kitten.

Your all-time celebrity crush just walked into the restaurant where you're eating.

You're all out of Sleepytime tea.

There's nobody there.

Everyone has food poisoning.

Someone starts an orgy and it's REALLY uncomfortable.

Oh hey, it's your boss!

There are puppies everywhere.

You empty your bank account.

You have a giant black salad tooth for the remainder of the evening.

Your breath smells like a pork truck for the remainder of the evening.

You swerve off the road to avoid murdering a family of baby ducks, hit a tree, and semipermanently rearrange your face.

You twist your ankle and literally fall into the gutter.

You are forcibly removed from the premises by a security guard while screaming, "JUST ONE MORE BITE OF THE POMME ANTIOXIDANT CRUCIFEROUS CRUNCH RAW BAR. PLEASE. I NEED IT."

BE A KID AGAIN AND FINISH THIS HAPPY STICK FIGURE DRAWING

Remember these? Draw a happy little cloud below, and remember that you are loved (and not about to get rained on).

anxiety check-in

Today is __/__/____.

I'm feeling: _____

The worst part of my day was: _____

The thing I did to make myself feel better was: _____

_____ (Flip to page 100 if you need some self-care suggestions.)

Here is something I did today that I'm proud of: _____

For that, I deserve a: _____

I also did these things, which are great: _____

I made someone else's day better by: _____

Now that I think about it, I'm pretty amazing.

PLACE THE SITUATION ON THE PAIN SCALE

 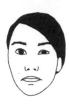 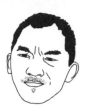 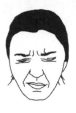

1　　**2**　　**3**　　**4**　　**5**　　**6**　　**DEAD**

—————— Roommate walks in on you having sex.

—————— Parents take you off their health insurance.

—————— Just withdrew money and now the screen is displaying your bank balance.

—————— Can't remember your iTunes password, spend twenty minutes trying to figure it out, finally reset password, and see this: "Your new password cannot be the same as your old password."

—————— Best friend got a book deal.

—————— Saw a spider and can't find it anymore.

—————— Your ex is dating someone new.

—————— Your ex has HPV.

—————— Your ex has died.

—————— Your ex is dating Scarlett Johansson.

—————— Watching pimple-popping videos on YouTube.

—————— Pulled up onto the stage during a stand-up comedy routine.

—————— Eating a rice cake.

—————— Someone is reading over your shoulder on the subway.

—————— A faucet is dripping somewhere.

—————— None of your socks have pairs.

—————— No coffee creamer left in the break room.

—————— Picked up a piece of fruit and there's mold on the other side.

—————— Filling out paperwork.

—————— Shopping at the Gap.

—————— Somebody called you instead of just texting.

"HELPFUL" ADVICE YOU GET FROM PEOPLE WHO DON'T HAVE ANXIETY

Mention you have anxiety, and all of a sudden everyone from your cousin Janice to Alisa the CVS night-shift cashier is an expert. Check off the words of wisdom with which you've been gifted.

☐ Have you tried one of those sensory deprivation tanks? They're so relaxing. Just your thoughts, the universe, and you. For hours.

☐ Studies have shown that stress can shorten your lifespan. You should try not to be so stressed.

☐ I bet a great new haircut would cheer you up. I'll give you my stylist's number!

☐ I felt exactly the same way—before I signed up for CrossFit!

☐ Wait, Dr. Oz did an episode on this! Let me just find it on YouTube real quick, hold on . . .

☐ It's probably just your age catching up with you.

☐ My uncle had a big anxiety problem. He died.

☐ If you went vegan, it would solve like 99% of your problems.

Vegan food!

lettuce

tofu

pepper

BRAGG
Premium
NUTRITIONAL YEAST
SEASONING
NET WT. 4.5 oz (127g)

CIRCLE ALL THE WEIRD ANXIETY DREAMS YOU'VE HAD

Teeth falling out

Everyone's dead

Didn't study for test

Medical experimentation involving syringes

Forgot to pack a suitcase

Buried alive

HERE LIES YOU, DEAD INSIDE BUT NOT OUTSIDE. WE'RE SORRY.

Lost the super-important thing

Naked in public

Pauly Shore is there

Parents hate you now

Aliens are after you

Face melted off

Can't move

Falling off a building

Apocalypse happening

Can't find the cat

JESUS FUCKING CHRIST

Put each letter into the correct space in the grid column directly above it to reveal that thing that needs to fucking stop happening to-fucking-day.

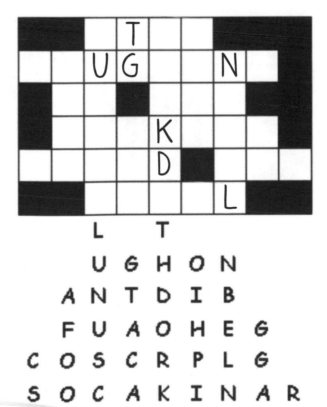

WEIRD ANXIETY BINGO

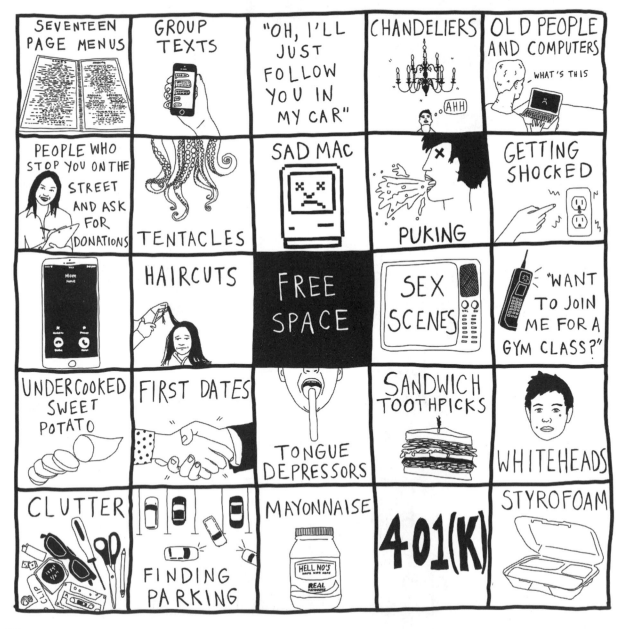

JUST A FEW THINGS TO KEEP IN MIND

If you notice something awesome about someone, it's almost always a good idea to tell them about it.

Tell the truth, even (especially) when you don't want to.

Own your successes — they're not just "lucky breaks."

When a friendship no longer makes sense in your life, even if you don't exactly know why, it's okay to let it go.

People's reactions are almost always less about you and more about them. Try to remember that before you decide how to let them affect you.

Guilt is not only a terrible emotion; it's a waste of time. So stop beating yourself up about not having hiked the Appalachian Trail/recorded an album/embarked on a career at the CIA. Figure out whether you actually want to do that thing, or just think you should want to. If it's the former, do it. If it's the latter, let that shit go.

And finally: Anxiety is not something to be embarrassed about. In fact, you should own an activity book about it. And you should do those activities on the train, so everyone reading over your shoulder can feel better about their anxiety, too.

ACKNOWLEDGMENTS

Our biggest thanks to Nina Shield, Megan Newman, Marian Lizzi, Justin Thrift, Jess Morphew, and the rest of the brilliant team at TarcherPerigee for letting us write a book about anxiety, thereby vastly reducing our personal levels.

Jordan:

Erin, thank you for being a (mostly) sane force of good in the world, and for never giving up in your quest to feed me things that are good for me, even though I do not like them. Thanks to Victoria, Becca, Reesa, and the rest of the team at DBA for being my cheerleaders for nearly a decade, and to Deborah Schneider and Cathy Gleason at ICM for your wonderful agent-ing.

Kendrick, I love you. Always will.

Thank you to my village of women, who know I'm a wreck and keep hanging with me anyway: Francesca, Morgan, Alisa, Erin, Elise, Mollie, Nes, Paige, Nadine, Katie, Ella, Thomasin, Becca, Kim, Audrey, Tia, Inga, Hannah Creek, Ali Jeronimo, Janet Ayala, and Magdalena Garcia. Mom, most of all. Thank you to Olivia for holding RG (and sometimes me) together. Thank you to Todd for being awesome, generally. And to Evan for being so, so there. River and Shea: I hope you don't inherit my anxiety, just because sleeping is more fun than not sleeping, but on the bright side, check out what it says on page vi! (You're two of the funniest and most brilliant and creative humans on the planet either way.)

But Dad—my partner in insomnia, and the first person who ever made me believe in superheroes—really: this one's for you.

Erin:

Jordan, thank you for *also* being a nervous wreck, but a smart, funny, creative one who likes to make books. Thanks to Paul Lucas at Janklow and Nesbit for never steering me wrong and answering all of my very anxious questions. This book was illustrated at The Wing, the most beautiful coworking space in existence.

Thanks to Mom and Dad, who've fielded many hysterical phone calls over the years. George—I can't believe you got a Razor scooter tattooed on your body because you lost a bet. Thanks to Joan Fortin and Art Gerard, who are lovely.

To the entire Clinical Data team at Flatiron Health, thank you for being funny and weird and, above all, kind: Emily, Stephen, Ricky, Larry, Selina, Ryan, Djamilia, Sasha, Nisha, Mariel, Shannon, Alex, Nacole, Julia, Dom (honorary), and Shreya. Thanks especially to Bryan Bowser, who is teaching me how to be cool (by Canadian standards, so, low bar) and Jocelyn Benson, a wizard, fashion guru, and truth-teller. Thank you, Jenny Edelston and Patrick Gonzales, for proving that laughter is the best medicine (besides actual drugs and, you know, medicine). Rebecca Rohrer and David Lenis: you guys make every single day better.

Thank you, Kate Novotny, for being my person. Kelley Linhardt: you are cosmically wonderful. Thanks to Evelyn Orlando, Reena Mueller, Stefan Samuelson, Mike Friedrich, Kevin Leal, Tiffany, Emily, and all the other smart people who remind me to be grateful, and occasionally humble.

My biggest thank-you is reserved for Kyle, who supports me in ways I never imagined a person could. Oh, and thank you, Lucy, for generating half the content for this book. I'm already having nightmares about you as a teenager. Disaster.

LET IT OUT.

LET IT OUT.

LET IT OUT.

LET IT OUT.